PAINTING WATERCOLOR BOTANICALS

First published in Great Britain
in 2019 by Ilex, a division of
Octopus Publishing Group Ltd
Carmelite House
50 Victoria Embankment
London EC4Y 0DZ
www.octopusbooks.co.uk

Published in North America by North Light Books,
an imprint of Penguin Random House LLC
penguinrandomhouse.com

Publisher: Alison Starling
Managing Editor: Rachel Silverlight
Junior Editor: Stephanie Hetherington
Art Director: Ben Gardiner
Designer: Eleanor Ridsdale
Production Controller: Emily Noto

ISBN 978-1-44030-091-2

Printed and bound in China

24 23 22 21 20 5 4 3 2 1

PAINTING
WATERCOLOR
BOTANICALS

HARRIET DE WINTON

NORTH LIGHT BOOKS

CONTENTS

INTRODUCTION

Painting Watercolor Botanicals comes from my desire to break the rules a little bit. I'm naturally messy, have always colored outside of the lines and I've never met a wobbly stem or wonky flower that I didn't love. No two plants are identical, so the same should be said for your paintings.

This style of painting combines the detail found in original botanical studies and the energy of loose watercolor painting. It appears effortless, but requires a relaxed confidence both in the painting process and in yourself. We are going to start right at the beginning, building that confidence with the basics of watercolor before moving on to flower and foliage studies.

Each project is broken down into steps with clear guidance on which mixes and brushes to use. You'll also find a simplified, scaled down version of each plant, perfect for wreaths and miniatures featured later in the book. The last chapter is a chance for you to get creative: color palettes and flowers combined in wreaths, patterns and borders, not to mention the adorable mini houseplant section.

Flower painting is a bit like being a florist: you're building an arrangement from scratch. I've broken up the plant studies into two groups – flowers and foliage – so that when we come to assemble our arrangements in the last section of the book, you will be able to visualize the stems laid out on your florist's workbench.

Whether you've never picked up a brush before or you're a seasoned pro, I hope that painting your way through this book will allow you to let loose and relax into this new botanical style.

WHY I LOVE FLOWERS

They grow in our gardens, decorate our houses and, in the case of many of us, they dominate our Instagram feeds. Flowers bring joy where there is sadness, whether in an abundant floral arch or a few stems in a cone of paper. They also smell nice.

My life and work revolves around them. I'm an artist and stationer who paints almost exclusively in watercolor, and I am commissioned to paint flowers more than any other subject matter.

The only thing I love more than a single flower is a whole bunch, complete with wild, overflowing greenery. Foliage is a thing of beauty all on its own – in fact, my husband and I even decorated our wedding venue exclusively with house plants and greenery.

I am a self-taught watercolorist with a patchy memory for flower names – it is safe to say I'm no traditionalist! My short time working for a florist introduced me to the seasonal swell of new blooms and color palettes. I would take this inspiration home with me every night to work on my watercolor commissions.

Being trusted to build a bouquet from the assorted buckets of blooms (and the pressure of assembling it under the customer's watchful gaze) provided me with both the inspiration and confidence to put together painted floral arrangements.

Narrowing down the list of plants to paint was a difficult task. I have chosen a variety of plants that bloom through the seasons, and that I delight in when they are in a vase on my desk. They also allow me to showcase numerous watercolor techniques and color combinations.

Flowers and watercolors are the perfect partners; like getting lost in the spiraling petals of a rose, the more you explore watercolor, the more you will discover its subtle surprises. I am still making discoveries after all these years, but the freshness of color racing across a wet page, triggered by a single dab of the brush, gets me every time.

MATERIALS

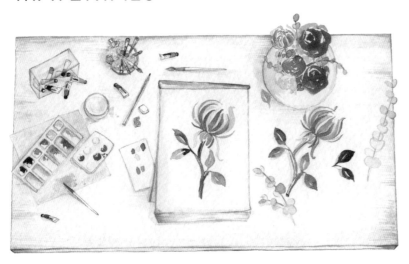

My initial attraction to taking up watercolor painting was the relatively small and affordable list of materials required: paint, paper, brushes and water. A good pencil and eraser are also helpful.

I use both high-end and mid-range products on a daily basis. I always tell my students to buy the best materials they can afford, and to treat them with great care.

Brushes
Every project in this book uses pointed round brushes of varying sizes (3/0, 0, 1, 2, 4, 6 and 8). This type of brush is brilliantly versatile: the bristles form a fine tip but are also thick enough to create a broad line. I love being able to paint a full piece with just one brush; I'm a fairly quick and instinctive painter, so I appreciate not having to change brushes every few minutes.

You will find a wide range of brush types on the market and it's worth experimenting with them to find what works for you. I recommend rigger brushes (long bristles, good for fine lines) and filbert brushes, which allow you to cover large areas quickly – perfect for putting down large washes before they dry up.

The best watercolor brushes are made of sable bristles (animal hair), but I have been very happy working with a range of synthetic-bristled brushes called Pro Arte Masterstroke. You know a brush needs replacing when it struggles to make a fine point.

Your brushes will last longer if you clean them thoroughly after use and never leave them bristles-down in a jar of water. The paint will flake off the handle of a brush left in water, making it uncomfortable to hold, not to mention the poor bristles will get bent out of shape.

Paint

I use both tubes and pans of watercolor; both have their advantages. Pans (dry, concentrated blocks of watercolor) are great to transport (they usually have a built-in palette in the lid) and last a lifetime. If you stick a paint-covered brush into the wrong pan, however, it can be a bit frustrating and messy. Tubes (fluid watercolor) are how I first started and I still have many from my original set, so they can also last a long time. Just remember that you only need to squeeze out the tiniest bit. I like to compare watercolor to food coloring: it is so concentrated that you only need a small amount to create a vibrant color. The water is the vehicle in which it travels.

Good-quality paints contain a far higher percentage of pigment, resulting in a more vibrant and long-lasting color. Brands such as Daler Rowney and Winsor & Newton have a student range and a professional range. The student range will have more binder and less pigment than the professional range, but the standard is still fairly decent. I use professional-quality Daler Rowney, but I would also recommend a few other brands, including Schmincke and Sennelier.

Paper

The projects in this book are done entirely on cold-pressed paper. It has a slightly mottled texture and soaks up paint and water in an even manner. You can also buy hot-pressed paper, which is smooth (good for tiny-detail projects and for digitizing your paintings, because the smooth paper scans well and is easy to rub out in Photoshop), and rough paper, which is so textured it is sometimes hard to paint a smooth stroke on it.

Paper quality depends on two things: what it's made out of and its thickness. Cotton pulp paper is the finest quality, but also expensive. The more affordable option is paper made from wood pulp. I am a big fan of the Langton paper, which is Daler Rowney's high-end cotton pulp paper, as well as paper blocks by Arches. I use Daler Rowney's Aquafine cold-pressed 140-lb. (300gsm) paper on a daily basis – it's a good standard paper thickness and the paper is fairly bright white, which keeps my paintings vibrant.

I buy paper either in pads (gummed at one edge) or blocks (gummed all the way around with a small gap, which helps prevent the paper from warping). In this book, the individual flower projects don't use too much water, so you don't need to worry about the paper warping – they can be done on a pad or a loose sheet with no problem. To minimize any chance of warping, you can always tape the sheet down on all four sides. Larger compositions with lots of water would be best carried out on a block or a pre-stretched piece of paper. Use up every corner of paper when practicing, and even turn the page over to use the other side if it hasn't been warped.

OTHER RECOMMENDED TOOLS

Palette
When using paint tubes, a ceramic plate works just as well as a palette. However, if you are working with plenty of wet color, it is wise to buy a palette with wells that separate the paint into compartments. You can buy plastic, ceramic and enamel metal palettes. Ceramic is best for mixing watercolors (which is why I often end up on a plate).

Water Jar
Any cheap glass, mug or container will do, as long as its sides aren't too high. I prefer a clear vessel so I can see when to replace the water. Painting with dirty water will inevitably affect the colors on your page.

Pencil and Eraser
I am not too worried about the make of pencil, as long as it has a lovely fine tip (so this section should also mention a good-quality pencil sharpener!). I use HB, 1H and 2H, working as lightly as possible (soft B pencils can smudge and affect the paint colors). If your drawings are too heavy, rub lightly with a kneaded eraser to fade the pencil line. Once pencil is painted over, you will struggle to rub it out, so make your lines as faint as possible. I try to keep pencil drawing to a minimum and allow the brushstrokes to dictate the shape and character of the piece.

Paper Towels
I always place my palette on the edge of a piece of paper towel to stop it from sliding about, and also to blot my brush dry. When blotting it like this, you will find any hidden paint lingering in the seemingly clean bristles, warranting another swish in the jar of water.

Your Workspace
When following these exercises, if you can have a physical flower or plant in front of you, you will get more out of the experience and make your own discoveries. Seat yourself at a table in a space with as much natural light as possible. I am lucky enough to have a studio with a rural view that constantly revitalizes me. Feeling good both mentally and physically in your environment is so important.

Washi Tape
Good-quality washi tape is great for masking areas. My brand of choice, MT washi masking tape, is low-tack (not too sticky) so it peels away cleanly, provided it is removed within hours of applying. To ensure success every time, I lower the tack (stickiness) on my tape by sticking it to my jeans once or twice before use.

WATERCOLOR BASICS

PAINTING TECHNIQUES

First we need to see what watercolor can do. Watercolor pigment is intensely concentrated so you need only the tiniest bit. Water is the vehicle for the color to travel, and it does most of the work.

The golden rule of watercolor is that your brush should always be wet. I don't mean waterlogged at all times, but the bristles need to be damp enough to hold paint, even when working on precise detail. Swish the brush around in your water jar and wipe the bristles on the rim a few times. This allows paint to flow from brush to page as smoothly as a felt-tip pen.

Throughout this book I will refer to the paint as wet, diluted or concentrated.

Wet: Plenty of water on the brush with plenty of color, allowing for broad coverage and bright, seamless blending.

Diluted: Plenty of water and very little color to achieve a pale, translucent quality.

Concentrated: Used most often for precise detail in the final stages of a painting. A good coverage of color on the brush with minimal water.

The following painting techniques are all carried out with a size 2 pointed round brush.

Dry-into-Dry
Applying concentrated paint to a dry surface, either a dry page or a painted page that has dried fully.

Your brush should never be bone dry, the term dry-into-dry refers to watercolor in its most concentrated form. Paint a concentrated circle on a dry page, similar to the one shown here – not very exciting, but the color is opaque and going nowhere on a dry page.

Wet-on-Dry
Applying wet paint to a dry surface, either a dry page or a painted page that has dried fully.

Clean your brush off and load it up with water. Now fill in that dry-into-dry circle with water, stroking the brush to pick up color from the inner edge of the circle, and watch the color blend inward. An initial sweep round will bring in a paler blue to fill the circle. A few more strokes will intensify the color to make a solid color circle. The outer edge of the circle remains crisp on the dry paper.

Wet-into-Wet

Applying wet paint to a wet surface when you want to create a soft, diffused edge and a seamless blend.

With a clean brush, wet a section of page, approximately a 2-inch (5cm) square. Working quickly – so that the water doesn't seep into the paper and dry – paint that same blue circle with your wet brush and watch the paint feather out. The more soaked your page, the more unruly your watercolor will be in its travels. It is tempting to poke and prod the watercolor tendrils, but it is always more effective when you let the paint do its thing undisturbed.

One application of water Three applications of water

Blending and Layering

When working on a composition, the adding of color will either be in the form of blending (wet-into-wet) or layering (wet-on-dry, dry-into-dry).

Blending: Blending colors involves a little restraint – it is so tempting to help the colors along, prodding them with your brush. This can lead to overmixing, which nearly always results in a dull, flat color – or at worst, a brown sludge. Read the Choosing Colors section (page 14) for more on choosing a fail-safe color palette.

Paint a wet circle, then choose a different wet color and paint a second, just overlapping it. As long as you are using enough water in your color mix, the paint will do its thing unaided.

Layering: Once a layer of paint is bone dry, you can add additional layers of color and detail with no fear of it bleeding. It is far easier to add a darker/more concentrated color to a lighter/more diluted one than the other way around. In the projects, I will always start with a light wash and build it up in intensity layer by layer. When it comes to the compositions in the last chapter, you will need to keep this in mind when you choose what to paint first.

CHOOSING COLORS

Each artist's palette has a different number of colors depending on how they like to mix each hue. I work from a fairly limited palette as I enjoy mixing color and discovering new tones. As a subject matter, nature boasts an astonishing range of colors and it requires a bit of experimentation to build the perfect color palette.

COLOR VALUE SCALE
Value is defined as the relative lightness or darkness of a color.

To experiment with different colors and see how they behave, paint a filled-in wet circle of color. Clean your brush off and paint a filled-in circle of just water that kisses the edge of that first circle – watch the paint burst into the wet space. Load up your brush with more water and paint another overlapping circle until you have what looks like a caterpillar walking off into the mist. The number of circles you achieve all depends on the amount of pigment in the first circle, the amount of water being used and the speed at which you work.

White watercolor pigment is often found in a pan of colors. It is a semi-opaque white, which can be used to create pastel tones. However, I don't use it, as I prefer to use water to dilute the pigment to produce lighter tones. The projects throughout this book rely solely on the use of water to create a spectrum of value.

When it comes to dark colors, I have cultivated a range of alternatives to using pure black. Throughout this book we will mix the dark, shadowy colors from brown, blue and red shades, which form far superior tones to that of black from a tube.

BUYING PAINTS
We use 14 colors in this book. They can be categorized as warm or cool. There are also earth colors – ancient earth pigments that help create a broader mix of colors for the palette.

Warm
- Sap Green
- Green Gold
- French Ultramarine
- Cadmium Red
- Cadmium Orange
- Cadmium Yellow

Cool
- Hooker's Green
- Prussian Blue
- Permanent Rose
- Cobalt Violet
- Lemon Yellow
- Cobalt Green Deep

Earth
- Ochre
- Burnt Sienna

I would recommend buying a set of paints that includes as many of these colors as possible. Each project has its own set of color swatches, so you can mix your colors to match if you don't have every color in the above list.

COLOR THEORY

In the last chapter of the book, you can apply your new botanical painting skills to create compositions. But how to choose the colors?

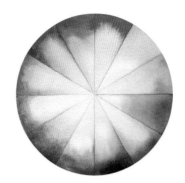

First, I choose whether my cool or warm tones are going to dominate the composition. While you can certainly use them together in a piece, they should not have equal value.

Complementary colors appear opposite each other on the color wheel – pink and green, blue and orange, yellow and purple. When placed next to each other at an equal intensity, they can seem like a terrible match. When used more subtly, however, they create brilliant and delicious combinations.

Pink and green form a complementary color palette that comes up frequently in this book. At equal vibrancy they compete with each other, but pair a blue-green with a diluted pink and it starts to make sense.

I create color palettes by exploring the potential of a pair of complementary colors, mixing each with the tones found on either side of them on the color wheel. For example, green can be added to with teals, blues and yellows; pink with orange, red and purple.

I pick approximately eight tones, making sure there is a balance of value: only a few concentrated colors, with the rest diluted.

To build your own color palettes, paint a wet circle of color and then paint overlapping circles of varied opacity and allow to blend. You will soon see which ones you want to pick out for your palette.

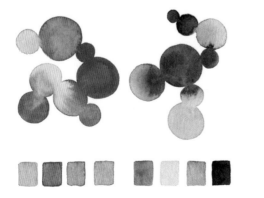

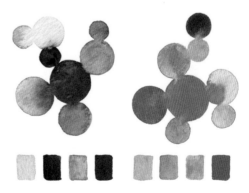

ANATOMY OF A FLOWER

A better understanding of a flower's basic anatomy will improve your drawing of it. By learning the terminology, you will also know which part I am referring to throughout the projects. This cherry blossom branch is labeled with terms that I refer to in my project instructions.

Bud: A compact growth on a plant that develops into a flower.

Petal: Surrounding the reproductive parts of flowers, often brightly colored or unusually shaped to attract pollinators. Together, all of the petals of a flower are called a corolla.

Sepals: Protection for the flower in bud, which then curl out and support the petals when in bloom.

Bud Eye: The beginnings of growth on a stem (also known as bract).

Branch: Any stem painted off the main stem.

Pistil: The central point of the flower (often what we paint first). The pistil comprises of the stigma, style and ovary; the female organs of a flower.

Stamen: The male fertilizing organ of a flower, typically consisting of a pollen-containing anther and a filament.

Anther: Oval-shaped structure at the top of the filament.

Filament: A slender stalk that supports the anther, which is where pollen develops.

Stem: The main body or stalk of a plant or shrub.

BUD

PETAL

SEPALS

BUD EYE

BRANCH

STAMEN
CONSISTS OF
ANTHER
&
FILAMENT

PISTIL

STEM

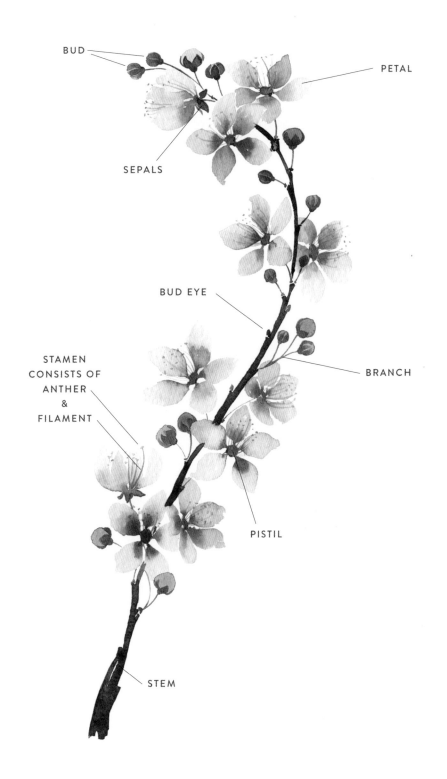

BOTANICAL BRUSHSTROKES

The new botanical painting style simplifies natural shapes into a series of key brushstrokes. There are three main strokes, which cover the botanical basics, but first you need to see what your brush can do.

We will be using a size 8 pointed round brush for these exercises.

LINES: THIN TO THICK

1.
You wouldn't think a size 8 rounded point brush would be the best for fine detail, but try painting the thinnest line you can with one anyway. Wet the brush and coat the tip with paint and paint a line just using the point of the tip.

2.
Now coat the full length of the bristles, first in water and then paint. Angling the brush low against the page so the full length of the bristles are touching the paper, sweep the brush sideways and see how thick a line you can paint. You will find the paint dries out fairly quickly. Try again with even more water on your brush and you will go further.

TAPERED LINE
The combination stroke to create a tapered line is the first of the three key botanical brushstrokes.

Starting with the tip of the brush, paint a fine line, and as you move the brush across the paper, press down so the full thickness of the bristles creates a gradually thickening line. Keep going and smoothly lift the brush back until just the tip is touching the page. You will have created an elongated eye shape. Play around with this stroke and see what different shapes you can make. This stroke will be referred to as a tapered line throughout the book.

C-CURVE

Now that you have mastered these strokes in a straight line, it is time to add some shape.

1.

Paint a curve that resembles the letter C with the tip of your brush. You are aiming for a line that maintains a consistent thickness.

2.

Keep each end of the C thin and the middle as thick as possible (essentially painting a tapered line in the shape of a C). Start with the tip of the brush and press the full thickness of the bristles down as the brush travels up and around in a curve, finishing with the tip in a controlled manner so the bristles don't flick out of control.

3.

The C-curve may not always closely resemble the letter C, but it still follows the same premise. Try a long, elongated stroke that curves in at both ends.

4.

The rose project consists of many layers of rough-edged C-curve petals. Add a bit of a wave to your C-curve motion, wiggling the brush a little as it comes round to create an uneven edge.

1

2

3

4

S-CURVE

The S-curve is the third botanical stroke, widely used in these projects.

1.

With the tip of your brush, paint an elongated S, maintaining a consistent thickness.

2.

Start the S with the tip of the brush and press it down as you reach the middle, finishing with the tip in a controlled manner so the bristles don't flick out of control. The angle of your brush should stay in line with the direction of the curve.

3.

An S-curve may not always resemble the letter S, but it still follows the same premise. This third version of the S-curve is commonly used when painting leaves. Angling your brush at 90 degrees to the S-curve, paint a thick S-curve but keep the brush low to the page to fill out the thicker section, creating a fuller line before lifting the brush to finish at the tip.

1

2

3

BASIC BOTANICAL STROKES: FOLIAGE

LEAVES

To create any leaf or stem, all you need are the three strokes outlined previously.

1.

When you pair two S-curves, you create a basic leaf shape. The unpainted sliver up the middle can be left as the central vein detail or filled in with water while still wet.

2.

To curve a leaf over to one side, pair a C-curve with an S-curve.

3.

To create a serrated edge, start with a pair of mirrored curves to create the basic leaf shape, and while still wet, paint a herringbone formation of small C-curves down each side of the leaf.

4.

You can create a full leaf by enlarging the herringbone formation from the previous step. Paint a central tapered line, then overlap it with stroke after stroke, forming the side and base of the leaf. Repeat on the other side.

1

2

3

4

LEAVES ON STEMS

1.

Paint a thin, elongated C-curve, and then another halfway up the first.

2.

Each leaf is created with a pair of curves, but begin the first curve with an extra-elongated thin line to act as the little leaf branch emanating from the stem.

3.

Fill your stem with leaves.

1 2 3

THIN LEAVES

1.

Some leaves are so slender, they only require a single curve. Paint a thin stem.

2.

Paint a single S- or C-curve from each stem.

1 2

BASIC BOTANICAL STROKES: PETALS

1.

A single curve or tapered line can create a slender petal, ideal for daisies. Start at the bottom with the tip of your brush and travel a few millimeters before pressing down the brush to create the petal's fullness. It is likely that the petal will have a fairly rough edge when painting in this direction. Alternatively, you can start at the top with heavy pressure, forcing the bristles into a fan shape, and gradually release the pressure as you draw the brush upward, finishing with the fine point.

2.

For a full petal, mirror two curves.

3.

Paint additional C-curves onto the wet petal shape. This would also be the point to drop in a second color at the base while still wet.

1

2 3

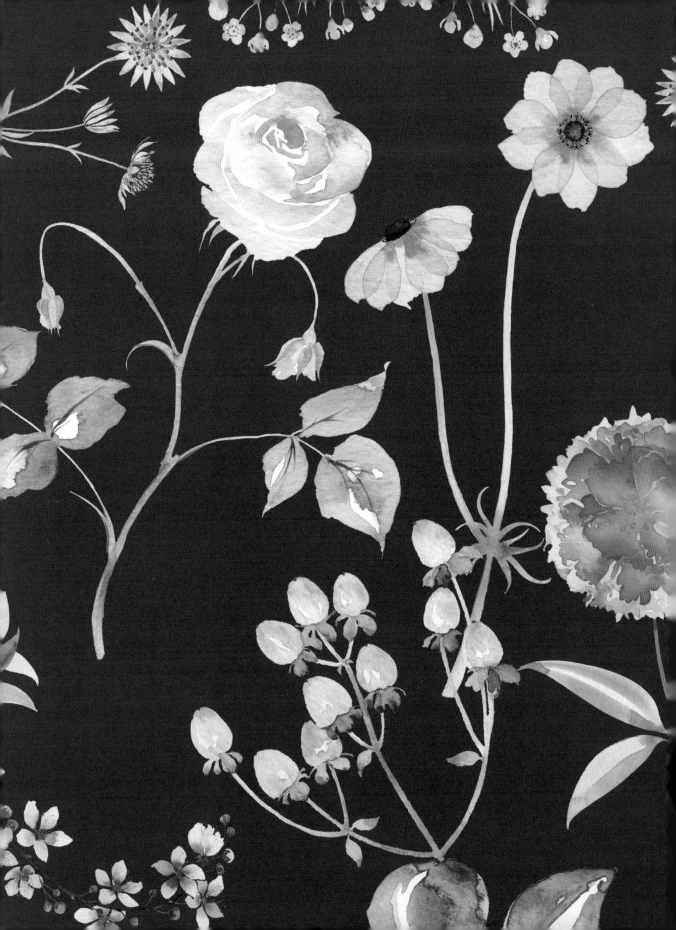

FLOWERS

TULIP

This is a brilliant starter project with endless color combinations. You need to work quickly, using lots of water to ensure the colors blend seamlessly through the petals.

WHAT YOU WILL NEED

Brush
Size 8

Colors

Sap Green

Permanent Rose

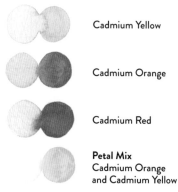

Cadmium Yellow

Cadmium Orange

Cadmium Red

Petal Mix
Cadmium Orange
and Cadmium Yellow

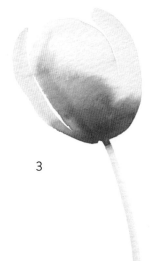

1

2

3

1.
Draw a faint pencil stem with a broad intersecting curve for the flower base, and paint a stem in wet Sap Green with your brush. To paint the central tulip petal, paint two elongated, mirrored C-curves in petal mix, and fill in the unpainted center with a clean, wet brush.

2.
While still wet, paint two petal mix C-curves on either side of the central petal that meet at the central base of the flower.

3.
While still wet, dab some concentrated Permanent Rose on the central flower base. If your petals are wet enough, the color will slowly blend its way up into the petals. Don't worry if a little blends down the stem as it adds to the character of the painting. Allow to dry fully.

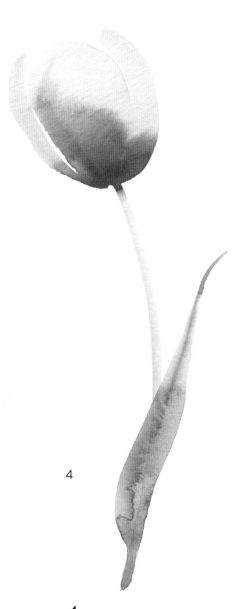

4.
Paint a tapered line in Sap Green with your size 8 brush from the base of the stem to create a tulip leaf.

1.
Draw a pencil stem. Paint one thick C-curve in diluted Cadmium Red with a size 0 brush. Mirror it with a thinner C-curve.

2.
Paint a stem in diluted Sap Green (allowing the red and green to touch and blend). Finish with a thick C-curve in Sap Green from the base of the stem to create a leaf.

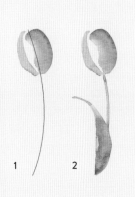

TULIP VARIATIONS

Tulips come in a vast array of varieties. The patterns on the petals cry out to be painted in watercolor. Why not try out some different wet-into-wet techniques to bring your tulips to life?

Tulip 1
Paint a tulip in petal mix with a size 8 brush and then immediately paint a line of wet Cadmium Red up the center and sides.

Tulip 2
Paint the tulip shape in petal mix and immediately drop in dots and lines of Cadmium Red using a size 0 brush.

Tulip 3
Allow the petal mix to semidry for 30 seconds, then paint Cadmium Red lines from the flower base upward with a size 0 brush.

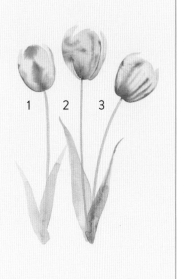

ANEMONE

This project relies on using plenty of water and minimal color to give a ghostly translucence to these blush anemones. There are points where you have to work fast while the paint is still wet to blend in the next step, and other times where you can make a cup of tea between steps while you wait for sections to dry.

WHAT YOU WILL NEED

Brushes
Size 0
Size 6

Colors

Sap Green

Prussian Blue

Permanent Rose

Cadmium Orange

Cadmium Red

Blush Mix
Cadmium Orange
and Permanent Rose

Inky Mix
Cadmium Red
and Prussian Blue

Dark Stem Mix
Sap Green, Cadmium
Red and Prussian Blue

Stem Mix
Sap Green and
Prussian Blue

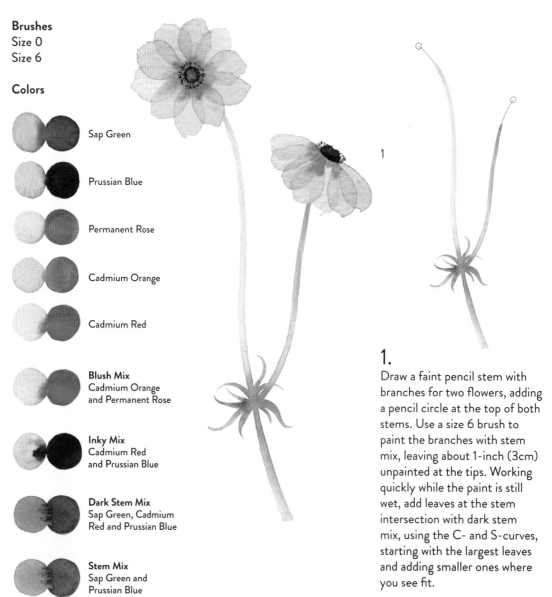

1

1.

Draw a faint pencil stem with branches for two flowers, adding a pencil circle at the top of both stems. Use a size 6 brush to paint the branches with stem mix, leaving about 1-inch (3cm) unpainted at the tips. Working quickly while the paint is still wet, add leaves at the stem intersection with dark stem mix, using the C- and S-curves, starting with the largest leaves and adding smaller ones where you see fit.

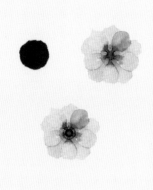

IN MINIATURE

Begin your miniature anemone with a central circle of inky mix, using a size 2 brush. Let it partly dry for a minute while cleaning off and loading up your brush with diluted blush mix. Touch the edge of the central circle with the tip of your brush to start the thin end of your petals. Allow a little of the inky mix to bleed into the petal shapes (the key to avoiding gray flowers is to do this step in a minimal number of strokes). Allow these petals to fully dry before painting a second layer of petals and a blush-colored halo around the central black dot. Once completely dry, finish off with a circle of inward-facing dashes and a double halo of dots using inky mix.

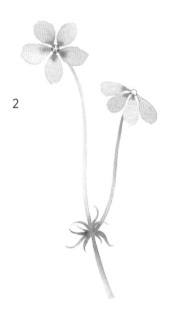

2

3

4

4a

4b

2.

Use the petal stroke to paint spaced out petals from the center of the pencil circles in blush mix with a size 6 brush. Try not to let the petal tips touch each other in the center. Dab some concentrated Cadmium Orange at these central tips while still wet and allow to blend.

3.

Allow the paint to dry and then repeat step 2, painting petals in the alternate spaces.

4.

Once the painting is completely dry, on the face-on flower paint a circle of inky mix dashes over the pencil circle with your size 0 brush. Blend into the centers with water.

For the side-on flower, start at the base of the dome with dashes that overlap and curve up around the dome to give it a textured outline. Fill in the shape by blending the color with water. Create a halo of anthers with your size 0 brush and the concentrated inky mix.

For the face-on flower, create two circles of imperfect, assorted dots, leaving a small gap between them and the flower's center. Fill the gap with fine dashes (filaments) radiating from the flower's center to the dots. For the side-on flower, allow the filaments to curl up around the sides of the central dome.

ROSE

For this project, having a real rose stem in front of you will make a big difference to your painting. The stem is a series of curves that extend out to leaf branches, one on top of another. To paint a rose in the loose style of watercolor requires throwing caution to the wind and really experimenting with the shapes you can make with your brush. No two loose watercolor roses turn out the same, so I have painted this rose clearly and simply. But by getting confident and creative with your brush, you can create a big bunch of varied blooms. Practice your rough-edged C-curve before tackling the rose.

WHAT YOU WILL NEED

Brushes
Size 0
Size 2
Size 6
Size 8

Colors

Burnt Sienna

Sap Green

Cadmium Orange

Cadmium Yellow

Prussian Blue

Leaf Stem Mix
Sap Green, Cadmium
Red and Prussian Blue

Leaf Mix
Sap Green and
Prussian Blue

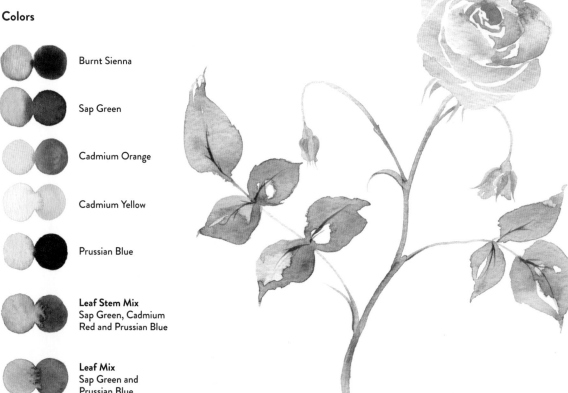

28

1.

Using a pencil, draw a faint series of curves, including the curving leaf branches and a broad intersecting curve for the flower base. Extend the stem up past the flower base, giving you a central line around which to anchor your petals. To paint a rose, start from that central pole and imagine you are wrapping layer upon layer of C-curves around it. The center of a rose is so tightly packed with petals, we can just see the tips, so paint three Cadmium Orange C-curves in a fairly tight bundle with your size 0 brush. You should be leaving small gaps between the strokes, but don't worry if they do catch and bleed into each other, your rose will look all the better for some irregularity.

2.

Coat a size 2 brush with a diluted Cadmium Orange and paint the next layer of wrapped petals: when painting a new petal, begin the C-curve at the broadest point of the previous petal, creating an overlap. When transitioning from tip to broad bristles, really press your brush down to create the thickest possible stroke before bringing it back up to the tip to finish off each stroke with as fine a line as you began with. Three overlapped C-curves tend to create a complete layer of petals, and each new layer requires broader C-curves than the previous one.

3.

Use your C-curves to form the shape of the rose, adding petals wherever you feel necessary. Work with an even more diluted Cadmium Orange and your size 6 brush to create the thickest petals. As the rose grows in size, you will need more than three C-curves to do a full layer. The more irregular your strokes the better, as these best replicate the uneven, curled outer petals of open roses.

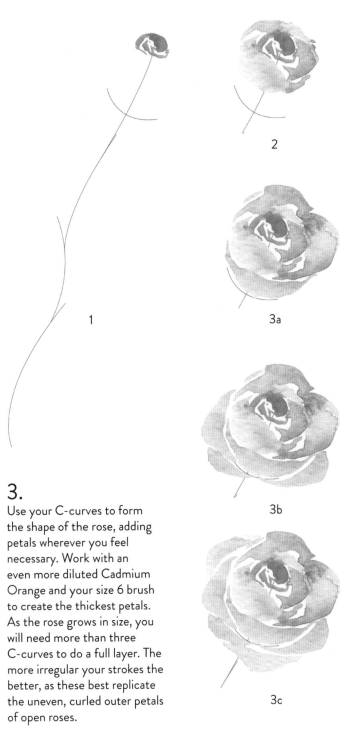

1

2

3a

3b

3c

COLOR-BLEND ROSE

To create a rose with more than one color, introduce a second diluted color to the petals at step 3. Watch the petals bleed into each other whenever a C-curve brushes into another.

4

5

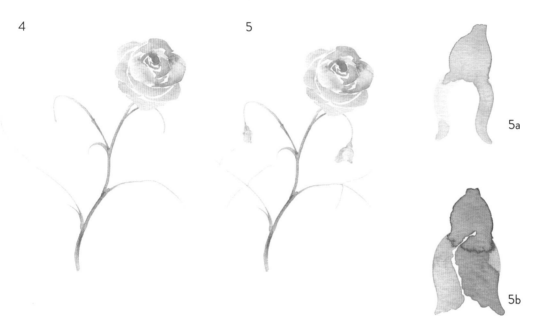

5a

5b

4.

Paint the central stem with a diluted Sap Green in your size 2 brush. While the stem is still wet, paint a few drops of diluted Cadmium Orange into the stem (roses often have a lot of the petal color running through the stem). Paint in branches for leaves and rose buds.

5.

Add leaf lines to the leaf branches in diluted Sap Green. To create the rose buds, paint a bulbous wet Sap Green head at the end of your bud branches with a size 2 brush. While still wet, clean off your brush and pick up some diluted Cadmium Yellow and paint two S-curve strokes that touch the wet green and gently bleed. Fill in the center of each bud with some diluted Cadmium Orange to create an overlapped petal. Allow to dry fully.

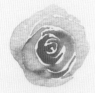

IN MINIATURE
The miniature rose follows the same steps as the main rose, just with a size 0 brush. Remember to start with a concentrated color and work your way out, adding water, not color, to the brush.

6

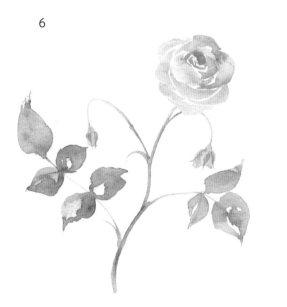

7

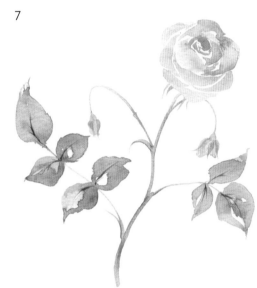

6.

With a size 2 brush, paint three S-curve strokes of Sap Green on each bud to create closed sepals. Use the already painted leaf lines as a guide for your leaves. Coat the entirety of your size 8 brush bristles in wet leaf mix. Paint two mirrored S-curves to create each leaf. Start with the tip of your brush from the end of the leaf line and conclude the stroke where the leaf line meets the main branch. The more irregular your brushstroke, the better – rose leaves have finely serrated edges. Allow to dry fully.

7.

Once fully dry, add a few Sap Green S-curve sepals to the main rose. With a concentrated leaf stem mix, use the tip of your size 2 brush to add a few central leaf lines to each leaf and to the underside of the branches to add a little depth.

DAISY

In spite of being relegated to weed status by some, no other flower conjures such delightful optimism and nostalgia as the daisy.
A flower that is doodled in notebooks, scattered in constellations across parks and gardens or artfully turned into daisy chains
– this is a firm favorite.

WHAT YOU WILL NEED

Brushes
Size 0
Size 2

Colors

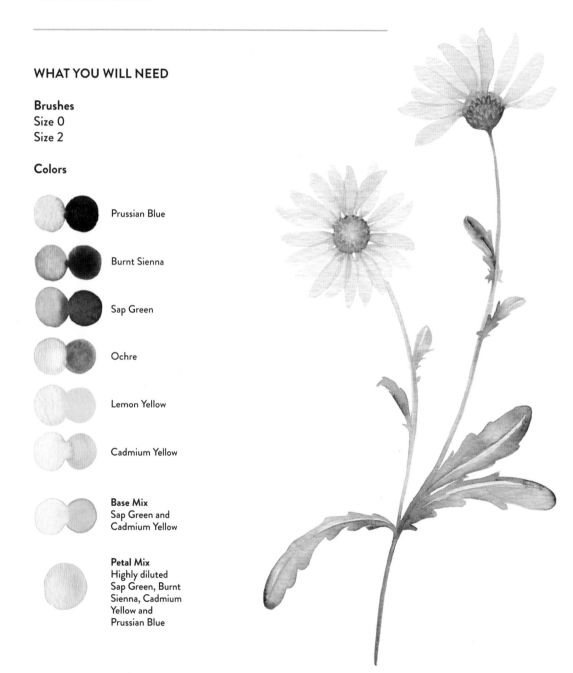

Prussian Blue

Burnt Sienna

Sap Green

Ochre

Lemon Yellow

Cadmium Yellow

Base Mix
Sap Green and
Cadmium Yellow

Petal Mix
Highly diluted
Sap Green, Burnt
Sienna, Cadmium
Yellow and
Prussian Blue

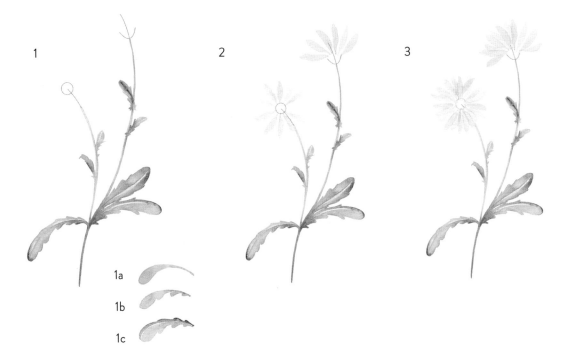

1

1a

1b

1c

2

3

1.

Draw a faint pencil stem with a branch for a second flower. With a size 2 brush, paint the stem in base mix, leaving a few centimeters of pencil stem at the top. For a face-on daisy, draw a faint pencil circle at the end of your pencil stem, and for a side-on daisy, a wide U a few centimeters from the end of the pencil stem for the base of the flower. Add in leaves – the largest sitting at the stem intersection – with wet Sap Green and a size 2 brush, sweeping the tip of the brush from the stem out in a C- or S-curve, gradually pressing the full bristles down to get a fuller leaf shape. Two of these brushstrokes create a single leaf with a narrow unpainted gap down the middle. Add in little leaf fronds while the leaf is still wet.

2.

For the face-on daisy, always start your petals from the center, working outward. Paint tapered-line petals with your size 2 brush using a diluted petal mix.

For side-on daisies, paint a fan of petals emanating from the pencil U. Leave space between each petal.

3.

Allow the paint to dry (you will be able to see any wet patches by holding it up to the light). Repeat step 2 in the gaps and you will get a delicate overlap of translucent petals.

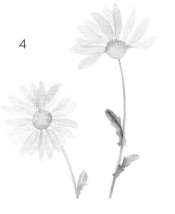

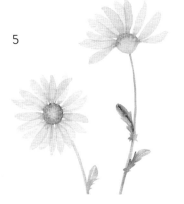

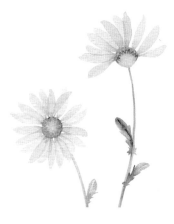

4.

Having left the paint to fully dry, paint a circle of wet Lemon Yellow in the center of the face-on daisy with a size 0 brush. Make it slightly larger than the faint pencil line (which should be hard to see by now). Add a little Cadmium Yellow inside the bottom half of the circle and allow it to blend.

For the side-on daisy, fill the U with diluted base mix. Dab a little Lemon Yellow, followed by Cadmium Yellow, along the top in the gaps between the petals.

5.

Once dry, take a tiny bit of Ochre on a size 0 brush and add dabs around the edge of the yellow circle of the face-on flower, creating a slightly frilled edge. Paint dabs in concentric circles, adding water but no more color to your brush to get a gradual fade with a textured look. Paint a little diluted base mix at the base of each petal and stroke the wet brush along the edge of each petal, letting the paint dilute to nothing. Once dry, add tiny dabs of Burnt Sienna around the outer edge of the circle, creating a little more depth.

For the side-on daisy, add a few dabs of Ochre along the top of the golden center in between the petals and some diluted base mix to the base of the petals.

6.

Now that your face-on daisy is finished, we can turn our attention to the final detail on the side-on flower. Get a tiny bit of Burnt Sienna on a size 0 brush and paint a fan of petal tips on the underside of the flower that touches the base of the daisy petals.

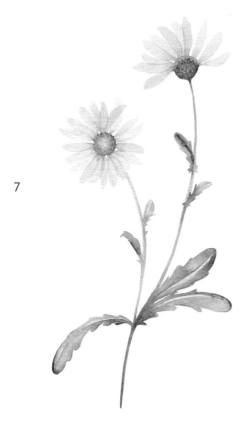

7

7.

On the underside of the side-on flower, paint more layers of Sap Green petal tips in the gaps, gradually working down toward the base of the flower. Finish off the base with a fan of concentrated Sap Green sepals and blend down into the stem.

IN MINIATURE

1.

The miniature daisy follows the same steps as the main project but you shrink down your brushes and remove the second flower. Having drawn a light pencil stem and flower head first, paint the stem and leaves with a size 0 brush. Allow to dry and form your petals around the central circle.

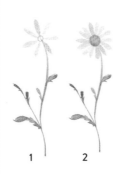

1 2

2.

Wait to dry and add a second circle of petals. Once dry, add a central circle of Lemon Yellow and dab Ochre in concentric circles.

DAHLIA

The pom pom of the natural world, the dahlia is one of my all-time favorite flowers. I always recommend starting your drawing by establishing the stem – this sets up the direction of the flower head and helps anchor the petals as you paint them. In this project we won't paint the stem until the flower is finished, but the initial pencil line will be invaluable.

WHAT YOU WILL NEED

Brushes
Size 0
Size 4
Size 8

Colors

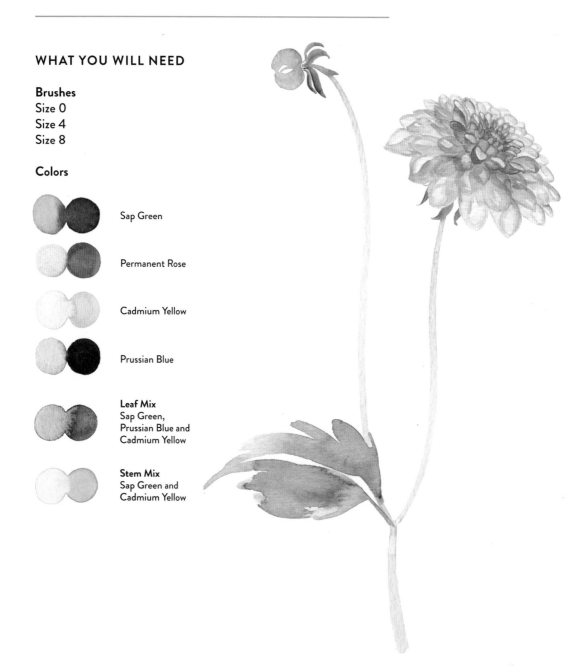

Sap Green

Permanent Rose

Cadmium Yellow

Prussian Blue

Leaf Mix
Sap Green,
Prussian Blue and
Cadmium Yellow

Stem Mix
Sap Green and
Cadmium Yellow

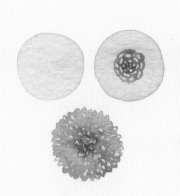

IN MINIATURE

Paint a circle in stem mix, allow to dry fully. With a size 0 brush, starting from the middle, paint a series of tightly bundled oval shapes in a concentrated Permanent Rose. Working quickly so the paint doesn't dry, paint layers of ovals with a wet brush (don't pick up any more color, the wetness will allow the color to blend through the channels) until you reach the edges. Finish off with petal loop shapes around the edge.

1.

Draw a faint pencil stem, marking the base of the flower with a small curve roughly ¾-inch (2cm) from the top of the stem. Draw a broader curve beneath the flower base, which will indicate the reach of your petals. Paint a dome in diluted stem mix from the flower-base curve to the stem top with a size 4 brush. Paint a fan of looped petals by outlining a teardrop shape in diluted Permanent Rose. Always start your petals from the curve of the flower base. Dahlia petals curl inward, creating the appearance of tubes; here we just want to create the rounded tips and the fullness of the petals. Add a little diluted Cadmium Yellow down the center of a few of the wet petals. Don't worry if you leave unpainted sections in some of the petals; in fact, I encourage it. Allow to dry fully.

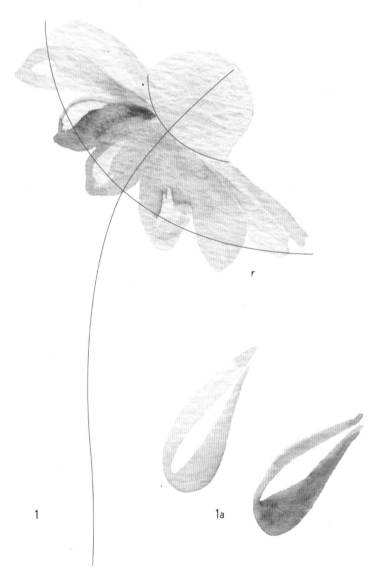

1

1a

2.

Paint a smaller second fan of looped petals on top of the previous one in a slightly less diluted Permanent Rose. You don't need to add any more yellow to these petals as it will glow through underneath. Allow to dry fully.

3.

Repeat step 2, adding another fan of petals with an even less diluted Permanent Rose. Use the central dome as the anchor for your petals and make sure they tilt upward a little more each layer. Allow to dry fully.

4.

Transition to a size 0 brush and repeat step 3 with a more concentrated Permanent Rose. Now that the petals are sitting up more, the trumpet-like tips of the petals are more visible. Allow to dry fully.

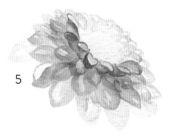 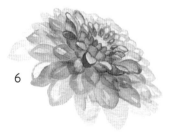 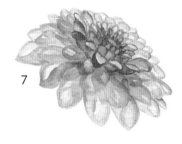

5.

Follow the outline of the dome to complete an inner circle of petals with a diluted Permanent Rose and a size 4 brush. Allow to dry fully.

6.

The last remaining circles of petals should stand upright, getting smaller toward the center. With a size 0 brush, paint the petals on the far side of the flower's center in a fainter Permanent Rose than those nearest to you. Allow to dry fully. Repeat with a second, smaller ring of petals. Allow to dry fully.

7.

Fill the remaining bald center with dashes of stem mix, circled by small dashes of Permanent Rose (the last little petals). Take the time to look over the rest of the flower and add petals where needed to give the flower a lovely round shape, or add a little more definition to the fainter petals.

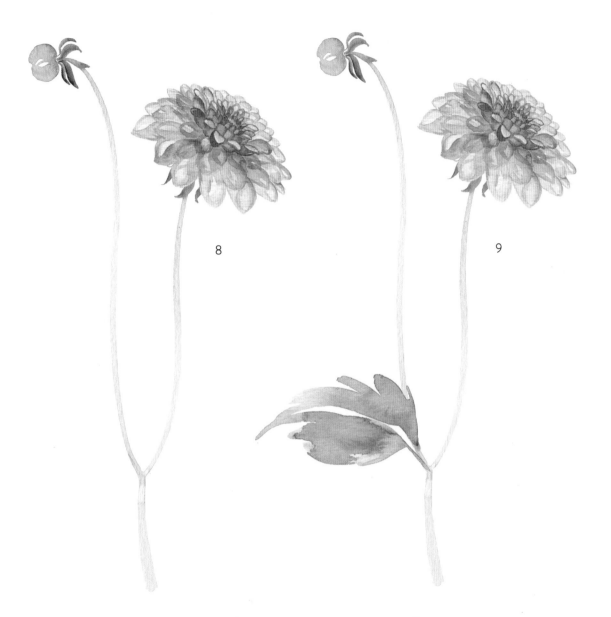

8

9

8.
With a size 4 brush, paint the stem in stem mix. Add a second stem and use the C-curve stroke to paint a small dahlia bud. Drop in a little Sap Green at the base of the bud while still wet. Add sepals with an S-curve stroke at the base of the bud, and just peeping out from the base of the flower.

9.
With a size 8 brush, fully covered in diluted leaf mix, paint a leaf with a serrated edge at the stem intersection.

RANUNCULUS

One of the trickier flowers to paint, for this project you will need to leave slivers of unpainted negative space between all the painted layers of the flower head, while also using lots of water to ensure the colors blend into each other.

WHAT YOU WILL NEED

Brush
Size 4

Colors

Sap Green

Permanent Rose

Lemon Yellow

Cadmium Orange

Cadmium Red

Blush Mix
Cadmium Orange
and Permanent Rose

Base Mix
Sap Green and
Lemon Yellow

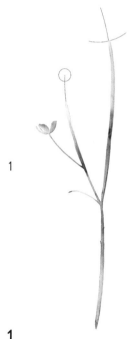

1

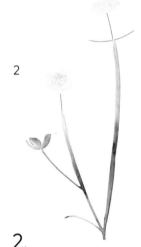

2

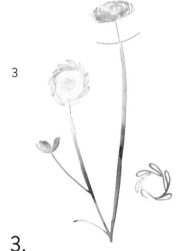

3

1.

Draw a faint pencil stem with branches for three flowers. Add a broad intersecting curve for the base of a side-on flower near the top of one branch, and a small circle on top of another for a face-on flower. Paint the stem in a wet Sap Green with your size 4 brush, adding a few upturned C-curve sepals at the end of the third branch.

2.

The face-on and side-on flowers follow the same technique, but you use a circular shape for the face-on flower and an oval shape for the side view. Using the tip of your brush, start with a dab of wet base mix and paint a few rounds of a messy, tight spiral for both flowers. It is important to leave little unpainted gaps, but try to avoid a perfect shape. Overlaps here and there are encouraged.

3.

You are now going to build up the shapes by adding layer upon layer of petals. Ranunculus petals are tightly packed and I have found the best way to depict them without getting lost is to paint a ripple-effect circle that gets a little bigger with each new layer. Paint the next few layers of petals in diluted blush mix, allowing the base mix to blend out into the pink.

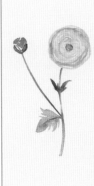

IN MINIATURE

With a size 0 brush, paint a curved stem with a branch in Sap Green. Paint two C-curves for bud sepals and S-curve leaves, following the instructions from the main project. For the face-on flower, start a tight spiral with wet base mix. Switch to blush mix as your circle grows. Paint two C-curves in Permanent Rose for the bud while the main flower dries. Once the face-on flower is dry, add a few dabs of Sap Green in the center.

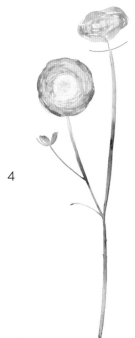

4

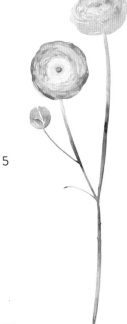

5

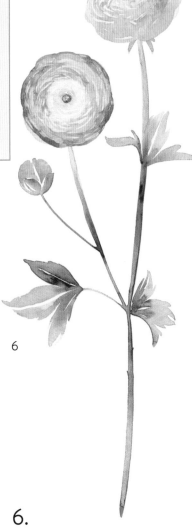

6

4.

For the face-on flower, continue to build up the petal layers with more wet, concentrated blush mix, and finally add a little wet Cadmium Red to the outermost layer. For the side-on flower, start to paint a few thick, overlapping C-curves around the edge.

5.

Finish off the side-on flower by painting a few C-curves in wet blush mix to fill out the base of the flower down to the pencil curve. Paint two mirroring C-curves in blush mix to create a bud on the third branch. Once the flowers are dry, add Sap Green to the centers, painting a circle of small dabs in the face-on flower and an oval swirl in the side-on flower.

6.

The ranunculus leaf is three-pronged with an irregular serrated edge. Using the steps below, paint leaves in wet Sap Green at the main branch intersection, and partway up the main stem. Add a few sepals under the base of the side-on flower.

6a

6b

6c

PEONY

From mid-May to early July in the northern hemisphere, Instagram feeds are in full bloom with posts from proud peony parents. The appearance of this romantic and glamorous flower signifies the start of summer, as they unfurl their never-ending frilly petticoats of petals at the turn of the season.

WHAT YOU WILL NEED

Brushes
size 0
Size 4
Size 8

Colors

Sap Green

Permanent Rose

Cadmium Yellow

Cadmium Orange

Stem Mix
Sap Green and
Cadmium Yellow

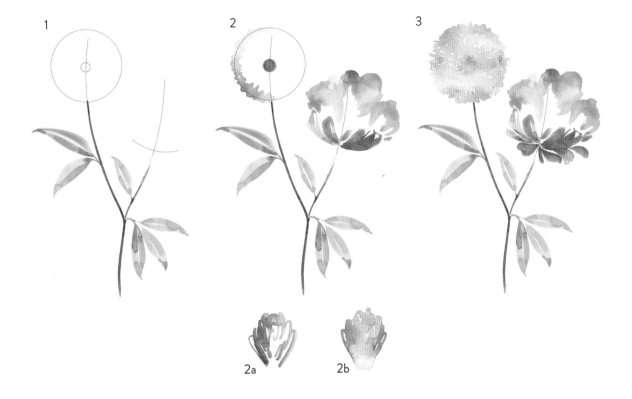

1
2
3

2a 2b

1.

Draw a faint pencil stem with a slight curve, and two branches. A few centimeters from the top of one of the branches, draw a wide curve, forming the base of the side-on flower. On the other stem, draw a large circle that will be the outer edge of the petals of a face-on flower. Mark the center of this circle, which should cross the stem. Paint the stem with stem mix on a size 8 brush, stopping below the pencil curves. For each leaf, paint two elongated, mirrored S-curves in Sap Green with a size 8 brush. Allow to dry.

2.

For the side-on flower, start to form the bottom cup shape of the flower. With a size 8 brush, paint C-curve strokes emanating from the flower base center in wet Permanent Rose. Then paint a halo of C-curves in a scribble style (see 2a and 2b) to create the top edge of petals. Make sure you leave the middle of the flower unpainted.

For the face-on flower, paint a wet blob of Cadmium Yellow in the center and drop in some Cadmium Orange. Working quickly with your size 4 brush, paint a scribbled line of wet, diluted Permanent Rose around the edge of the circle.

3.

Paint a few unfurled petals emanating from the side-on flower's base in Permanent Rose. Allow to dry fully

For the face-on flower, continue to paint a messy scribble in concentric circles until your wet brush touches the central circle. Leaving white gaps is fine, you will be adding layer upon layer so ensure this first layer is as pale as you can get it. The central yellow mix will blend out of its own accord, so resist the temptation to overblend it with the pink. Allow to dry fully.

4.

Fill in the side-on flower's center with petals, painting strokes of diluted Permanent Rose that always emanate from the flower base.

To create layer upon layer of petals on the face-on flower, you want a slightly more concentrated version of the Permanent Rose than before, but again keep it very wet. Imagine the petals emanating from the central point and paint scribbled outlines of petals (see steps 2a and 2b). Then fill them in with a clean, wet brush, blending the color down from the outline so that there is hardly any color making it to the center of the flower. Allow to dry fully.

5.

While still wet, paint a little diluted Cadmium Yellow in the center of the side-on flower. Add extra diluted Permanent Rose petals to the flower base to build the shape. Allow to dry fully.

Repeat step 4 for the face-on flower with a slightly more concentrated Permanent Rose. Allow to dry fully.

6.

Paint stamens in the centers of both flowers in concentrated Cadmium Yellow with a size 0 brush.

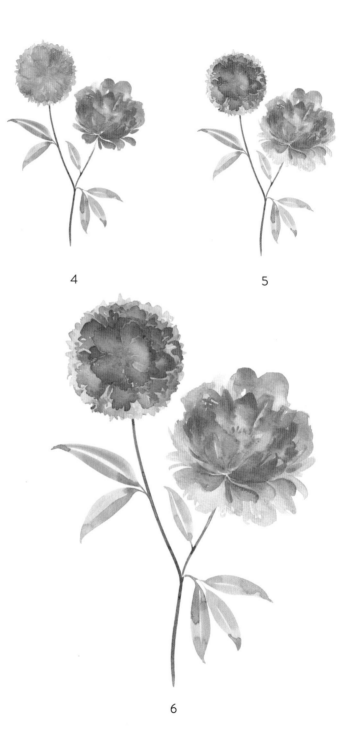

4

5

6

FACE-ON PEONY IN MINIATURE

1.
Using the tip of a size 2 brush, paint a tight spiral about
½-inch (1cm) across in Permanent Rose.

2.
Clean your brush and use its wetness to paint diluted
U-shaped curves that just touch the outer rings of the spiral
and draw some color out. Fill in each U by scribbling the
brush a little.

3.
Paint enough petals so that they all join up. Allow the paint to
slowly blend of its own accord. Drop a few dabs of Cadmium
Orange around the edge of the remaining spiral.

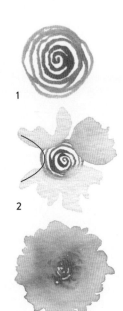

SIDE PEONY IN MINIATURE

1.
Paint two mirroring C-curves with wet blush mix
on a size 2 brush.

2.
Adding only water, no more color, paint several more
C-curves for slowly unfurling petals.

3.
Once semidry, paint one last stroke of wet blush mix up the
unpainted center and a few small C-curves coming away from
the flower base for fully unfurled petals.

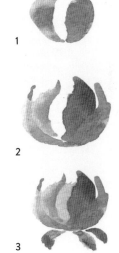

HYDRANGEA

The hydrangea is one of the last flowering shrubs standing as summer turns to autumn. They are as lovely dried as they are fresh, and their ethereal colors have a nostalgic quality. I can recall hours of fun had as a child making "perfume" out of their squashed petals.

Hydrangea flowers usually have four wide petals that overlap a little. Have a practice session painting the petals before putting them into a composition and play around with your color blends. You need only the tiniest amount of color and plenty of water to achieve the delicate tones.

WHAT YOU WILL NEED

Brushes
Size 0
Size 2
Size 8

Colors

 Sap Green

 Cadmium Yellow

 Prussian Blue

 Base Mix
Sap Green and
Cadmium Yellow

IN MINIATURE

1.
Draw a faint pencil stem with an oval for the flower head. Get some wet Prussian Blue on your size 0 brush and paint a small flower of four looped petals within the oval.

2.
Add more water to your brush and proceed to paint more petals, touching the previous sets. Add a little diluted Sap Green and keep painting the loopy petals. The wetness will travel across the grid of loops you have made and blend the colors beautifully. Fill the whole oval shape.

3.
Paint a Sap Green stem and leaf branches, then add wet S-curve leaves with serrated edges. Add a little Prussian Blue to the wet base of the leaf and allow to blend.

1

2

3

HOW TO PAINT A HYDRANGEA PETAL

Paint two mirrored S-curves, making a squat petal shape. Fill in the middle by blending the color in from the sides with a wet brush. While still wet, dab a concentrated dot of color at the bottom tip. Allow it to blend as it dries.

 a b c d

1.
Draw a faint, curved pencil stem. Then draw a large oval with the top of the stem at its center. To fill the hydrangea flower head, paint pairs of petals scattered across the oval with a size 2 brush and diluted Sap Green. Every time you paint a petal, drop a dab of Prussian Blue at its tip, which will be at the flower's center. Think about how the petals will sit toward the edge of the oval – squash a few to make it look like they are on the edge of a rounded flower head. Allow to dry fully.

2.
Repeat the hydrangea petal technique, completing each pair with two more petals. Use a size 0 brush from now on for better control. The petals will start to touch and overlap – try to leave a slender, unpainted gap between overlapping petals. Allow to dry fully.

3.
Fill your oval with flowers, but don't be scared to have unpainted gaps. Allow to dry fully.

4.
Paint the stem and parallel leaf branches in base mix with the size 2 brush. With the size 8 brush, paint big wet S-curves in base mix to create the broad hydrangea leaves. While still wet, use a size 0 brush to push the wet paint into serrated leaf edges and drop some Sap Green at the base of the leaves. Add two leafy sepals using the same technique.

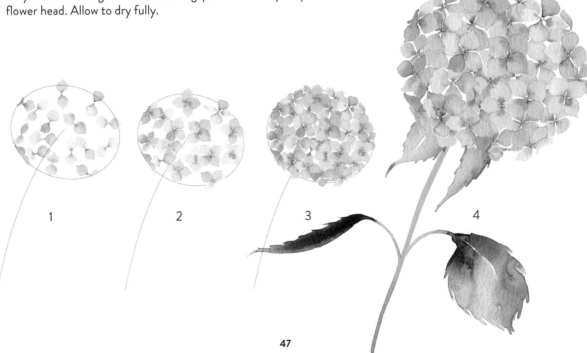

1 2 3 4

PROTEA

Growing abundantly in the southern hemisphere, proteas have made the long journey north and are the darlings of many cutting-edge florists.

Painting them is no mean feat: this project has many steps, and to paint a protea successfully relies on your enjoyment of watching paint dry. The first three steps require quick work to blend the colors while the paper is still wet. From then on it is slow and steady to the finish line as we add layer upon layer of crisp petals.

WHAT YOU WILL NEED

Brushes
Size 4
Size 1
Size 2

Colors

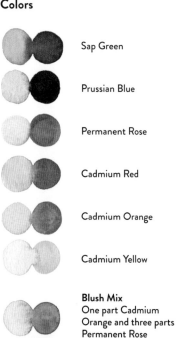

Sap Green

Prussian Blue

Permanent Rose

Cadmium Red

Cadmium Orange

Cadmium Yellow

Blush Mix
One part Cadmium
Orange and three parts
Permanent Rose

Dark Stem Mix
Cadmium Red
and Prussian Blue

Base Mix
Sap Green and
Cadmium Yellow

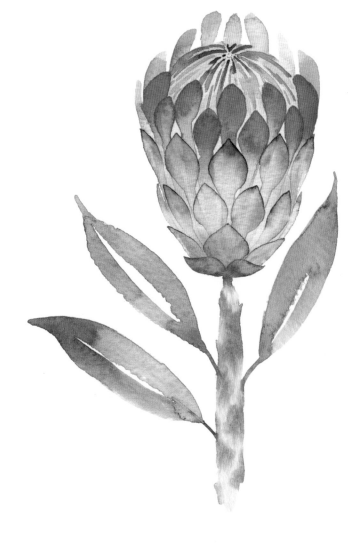

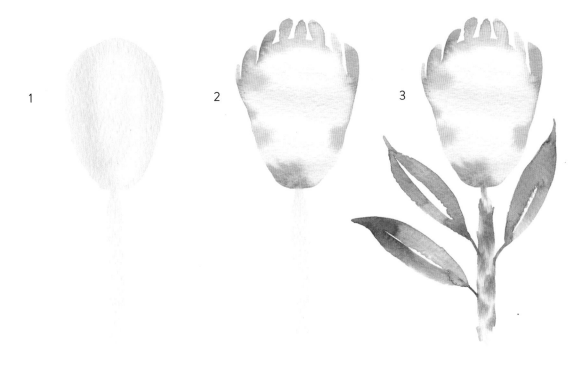

1.

With an extremely wet base mix on your size 4 brush, paint a thick stem (approximately ½-inch [1cm] wide) that tapers upward into a thin point. Paint an upside-down egg – a bit more bulbous at the top – as your flower head shape, and fill it in.

2.

Working quickly while the base is still wet, coat your brush in a wet blush mix and paint a halo of petal tips around the top of the protea. They will seamlessly blend into the base shape if it is wet enough. The more imperfect the petals are, the better, but be mindful that they should always emanate from the central base of the flower. Take a brush full of diluted dark stem mix and dab the brush on the central base, allowing the color to spread into the wet base.

3.

Paint small, imperfect vertical strokes of dark stem mix down alternate sides of the wet stem to create a rugged surface. Paint a few thin leaf branches, angled upward. Clean off your size 4 brush and cover it in wet Sap Green. Paint two mirrored, elongated S-curves to create each leaf. Now sit back and admire your handiwork as it dries.

4 5 6 7

4.

Before adding the petals, I recommend you have a go on a separate piece of paper to perfect the shape. Protea petals remind me of chunky plastic teaspoons: a slightly pointed oval end that elongates into a long thick neck. Starting in the center, with a size 4 brush, paint the round tip of a petal with a wet, concentrated blush mix. Clean your brush thoroughly but leave it wet and paint a clear line of water up from the base of the flower to meet the petal's tip. Allow the pink from the petal tip to blend and fade down the wet channel. This is the best way to quickly and seamlessly blend the color. Complete the semicircle of petals, making sure they don't overlap. Each layer of the protea's petals is surprisingly spaced out. Leave to dry.

5.

Repeat step 4 one level down in the alternate spaces.

6.

This is another repetition of step 4, but change the color to wet base mix. This might be tricky to see over the pink beneath. If you are bothered by the pale pink outlines underneath, you can gently blend them out by carefully smoothing the wet brush over them and reactivating the dry paint. Finish off this petal by painting a crisp top edge of concentrated dark stem mix with a little extra Permanent Rose on your size 1 brush. Allow this injection of dark color to swirl about in the pale petal. As it dries, the color will rush to the edges, creating a crisp outline. Complete the semicircle and allow to dry fully.

7.

Repeat step 6 until you reach the base of the flower. Leave to dry fully between each layer.

8.

To create the central dome of filaments, find a central point and mark it lightly with pencil. Using your size 2 brush and a wet blush mix, paint thin, curved strokes from the outer edges to the middle from all sides. While the brush is still wet, pick up some dark stem mix and drop it into the center of the dome where the strokes meet: watch it sail down the wet blush strokes, blending beautifully.

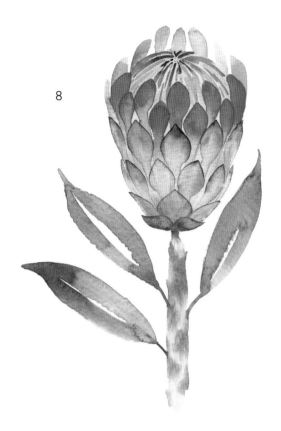

8

IN MINIATURE

1.
Using your size 2 brush, add a tiny bit of Permanent Rose to your base mix and paint a mini stem and an egg shape for the flower. Add a tiny bit more Permanent Rose to the mix and paint small dabs of this color down the stem. Clean your brush and pick up some diluted Sap Green. Starting at various points of the stem with the finest tip of the brush, stroke the brush upward and outward, pressing down to create the thickness of the leaf and easing off pressure to finish on the tip of the brush, creating your leaf point. Leave to dry.

2.
With the blush mix, paint lines of simple petal-shaped dabs, starting at the top and making sure each lower layer fits into the alternate gaps left by the previous line. Continue to the flower base.

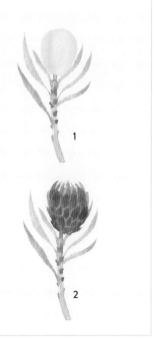

1

2

CHRYSANTHEMUM

Most likely to be seen languishing in cellophane at gas stations, chrysanthemums get a raw deal. These late autumn blooms are criminally underestimated, boasting a wealth of special varieties.

WHAT YOU WILL NEED

Brush
Size 4

Colors

 Sap Green

 Cadmium Red

 Cadmium Orange

1

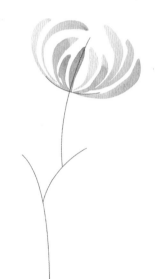

2

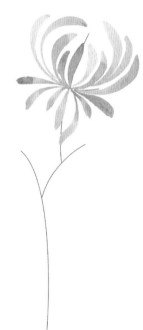

1.

Draw a faint pencil stem with curved leaf branches and a broad intersecting curve for the flower base. Dilute Cadmium Red and Cadmium Orange on your palette. You aren't premixing a color, but as you paint the petals, create a range of shades by picking up a little of each on your size 4 brush in varying proportions. Paint C-curves to form the central cup of petals. Press down your brush at the tip of each petal to create a softer, bulbous end as opposed to a pointed tip.

2.

Using the same technique outlined in step 1, paint a few petals that have unfurled downward. Allow to dry fully.

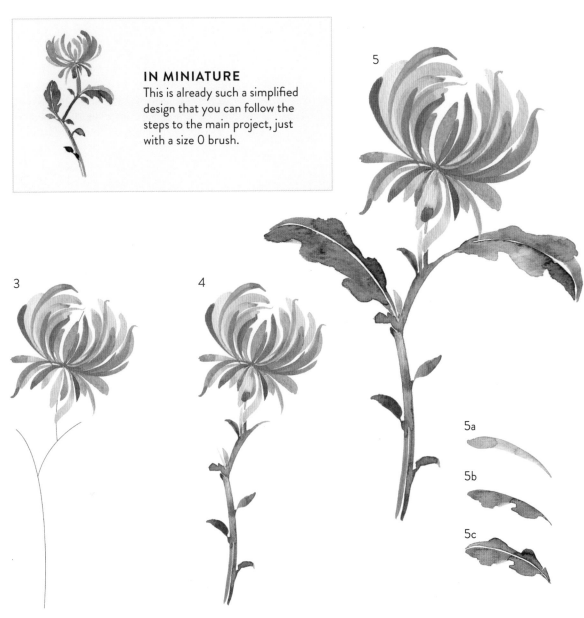

IN MINIATURE
This is already such a simplified design that you can follow the steps to the main project, just with a size 0 brush.

5

3

4

5a

5b

5c

3.
Paint a new layer of petals with more concentrated versions of Cadmium Orange and Cadmium Red.

4.
Chrysanthemums have broad, ridged, gnarly stems. Paint two parallel lines in wet Sap Green for the stem and blend together at points with water. Add a few small leaves, using a fine tip for a small stem, and pressing down into the fullest stroke of your bristles to create a broad leaf shape. If you have spaces between the unfurled petals, add a few sepals at the flower base.

5.
Create the main leaves, starting with a wet Sap Green C-curve that begins with a fine point at the base and broadens out to a rounded end. While still wet, push the paint on the outer edge into a wobbly leaf shape. Paint a second parallel C-curve with a small gap between the two, pushing the wet paint on the outer edge to create a wobbly leaf shape as before.

AMMI

This plant has delicate white, lacy flowers. While it is a brilliant filler flower in an arrangement, it also makes a beautiful white cloud of petals when arranged on its own.

This project uses just one color mix. You will start by using the most diluted version, and gradually build up more concentrated layers.

WHAT YOU WILL NEED

Brush
Size 0

Color

Ammi Mix
Sap Green,
Cadmium Yellow
and Prussian Blue

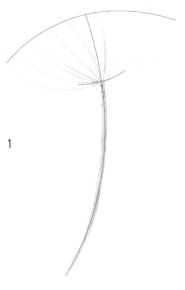

1

2

2a 2b 2c 2d

1.

An ammi's stem and branches resemble an inside-out umbrella: a stem with a small intersecting line from where the fronds will protrude with a broad curve across the top to indicate where the branches end and the flowers begin. Once you have drawn that and rubbed it out so it is faint, paint over the lines in a very diluted ammi mix with a size 0 brush. These branches will be the background fronds, so space them out as you will be painting another batch in a few steps' time.

2.

With a slightly more concentrated ammi mix, use the tip of your size 0 brush to paint a fine line from the main stem to create a leaf stem. Use mirrored S-curves and a central tapered line to create three-pronged leaves.

IN MINIATURE

This mini ammi follows the same order of steps as the main project – stem and branches first. If you're feeling confident, use the finest tip of a size 0 brush to create two parallel lines for the stem, leaving the center unpainted to create a little bit of depth. For the florets, take diluted ammi mix on a wet brush and dab your brush at random across the top curve of the branch ends.

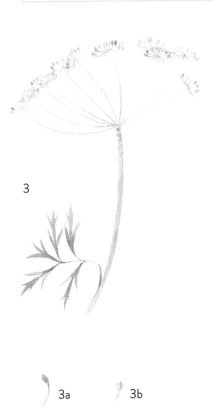

3

3a 3b

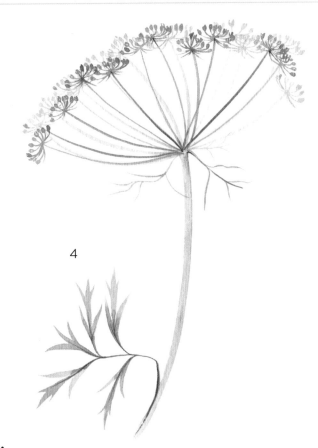

4

3.

Each fan of flowers atop the branches is like a miniature version of a full-scale ammi. With the original diluted ammi mix, use the tip of the size 0 brush to create a miniature branch and press the tip down to create a tiny, closed flower.

4.

Once that layer has dried, paint additional foreground branches and flowers in a more concentrated version of the ammi mix. You can also add a little more depth to the leaves by running the fine tip of your brush along the edge of the leaf stem and down the middle of each leaf. Finish off with a few forked sepals from the base of the branches.

WAXFLOWER

When I worked as a Saturday girl in a florist, the waxflower was a name I could easily remember, so I loved recommending it in every bouquet. It is a beautiful addition that always has a range of flowers in differing stages of bloom on one stem. We cover them all here.

WHAT YOU WILL NEED

Brush
Size 0

Colors

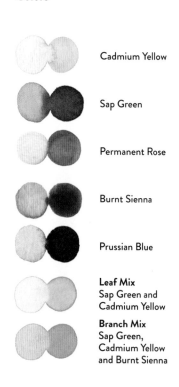

Cadmium Yellow

Sap Green

Permanent Rose

Burnt Sienna

Prussian Blue

Leaf Mix
Sap Green and
Cadmium Yellow

Branch Mix
Sap Green,
Cadmium Yellow
and Burnt Sienna

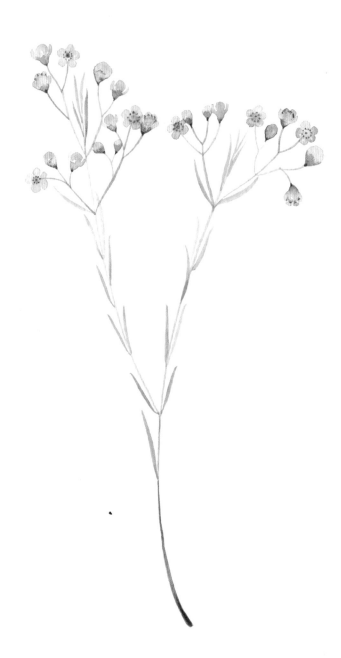

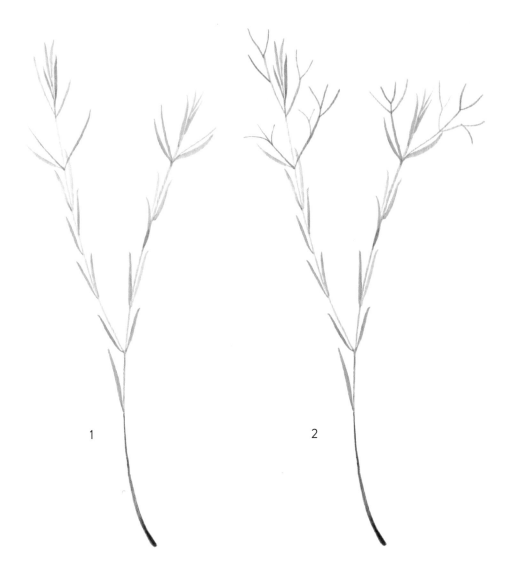

1.

Draw a forked stem in pencil and add some branches toward the top of each side. Using a size 0 brush, paint the stem in diluted Burnt Sienna. While still wet, add a little Prussian Blue at the base and allow it to bleed upward. Add long, thin tapered-line leaves in leaf mix up the stem.

2.

Paint some smaller forked branches in branch mix. There are always a few that have a third branch, so add in a few extras.

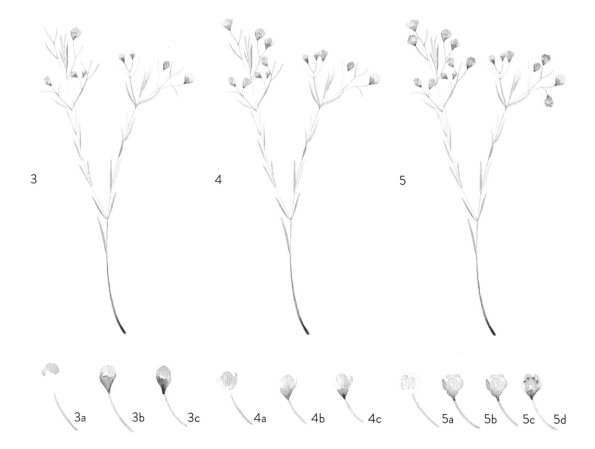

3

4

5

3a 3b 3c

4a 4b 4c

5a 5b 5c 5d

3.

First create the buds by painting a small C-curve in diluted Permanent Rose, just hovering over the end of a branch. Then paint an upturned cone in diluted leaf mix, allowing it to just about touch the pink at the end points. Finish with a dab of Sap Green at the base of the wet cone. Adorn a selection of branches with buds.

4.

Now for the side-on, partially opened flowers. Paint a central petal blob and a C-curve either side in diluted Permanent Rose just hovering above a branch end. Then paint an upturned cone in diluted leaf mix, allowing it to just about touch the pink. Finish with a dab of Sap Green at the base of the wet cone. Paint these on a selection of branches.

5.

Next are the partially open flowers angled toward us. Paint a central petal blob, a C-curve either side and two more over the top in diluted Permanent Rose, just hovering above a branch end. Then paint an upturned cone in diluted leaf mix, allowing it to just about touch the pink. Paint a dab of Sap Green at the base of the wet cone. Dab small dots of leaf mix between the front and back petals, and add a small amount of Burnt Sienna while they are still wet. Paint these on a selection of branches.

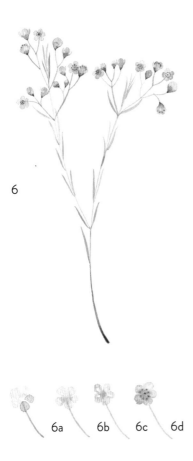

6

6a 6b 6c 6d

6.

Finally, create the fully open flowers by painting a fan of five petals in diluted Permanent Rose. Then drop a tiny dab of diluted leaf mix into the center, followed by a dab of Sap Green. While semiwet, paint a circle of Burnt Sienna dots and place one in the center. Paint these on the remaining bare branches.

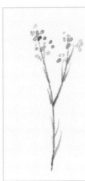

IN MINIATURE

Using a size 0 brush, paint a forked stem in Burnt Sienna and add a few parallel leaves in leaf mix. Paint clusters of dots in diluted Permanent Rose on the top third of the stem.

SEA THISTLE

Despite their appearance, thankfully, the sea thistle's fronds are soft, sparing the fingertips of the florists and painters handling them.

It's a good idea to create your color mixes in advance so that they are close by when you need them. The thistle mix uses only a tiny amount of Permanent Rose as you still want it to be blue rather than purple.

WHAT YOU WILL NEED

Brushes
Size ³⁄₀
Size 0
Size 2

Colors

 French Ultramarine

 Sap Green

 Permanent Rose

 Cadmium Yellow

 Prussian Blue

 Dark Mix
Sap Green and
French Ultramarine

 Base Mix
Sap Green and
Cadmium Yellow

 Thistle Mix
Prussian Blue and
Permanent Rose

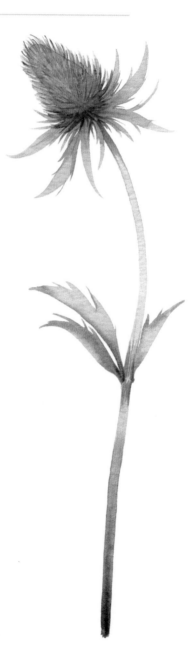

1.

Draw a faint pencil stem that is long and curved. With a size 2 brush, paint a stem and thistle head in wet base mix. While still wet, drop some dark mix into the base of the stem and allow it to bleed upward.

2.

Paint a cluster of S-curve strokes part way up the stem in wet base mix with your size 2 brush. While still wet, add points along the leaf edges with a size 0 brush, using wet dark mix that will blend into the leaf (see 2b). Use the same technique to create a collar of sepals at the base of the thistle head. Finish by dabbing wet Prussian Blue at the center of the base of the thistle head and allow it to bleed out into the sepals. Leave to dry fully.

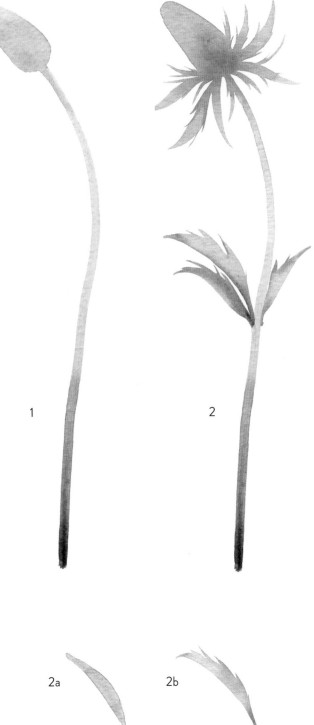

1

2

2a

2b

3

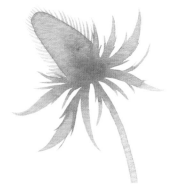

4

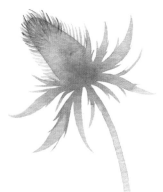

5

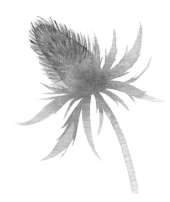

3.

With your size 0 brush, paint a fringe of filaments in diluted base mix, angled upward toward the tip of the thistle head. Allow to dry fully.

4.

Focusing on the top third of the thistle head, paint a series of C-curves in diluted thistle mix with the tip of your size 0 brush. Clean your brush off and with the same wet brush, paint a few more C-curve strokes across the bottom of your painted third to blend the bottom edge of the filaments. With a little Prussian Blue on your size ⅜ brush, paint a few stronger blue filaments at random within your painted third.

5.

Working your way down the thistle head, repeat step 4.

6

7

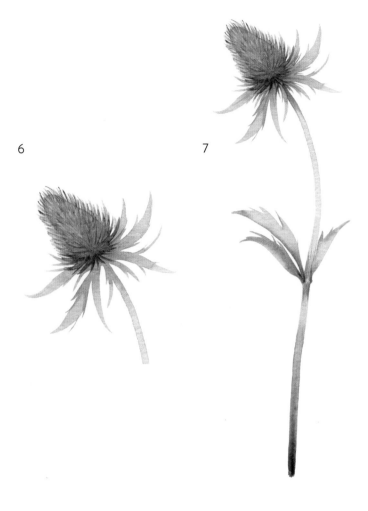

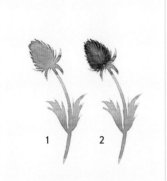

1 2

IN MINIATURE

1.
With a size 0 brush, paint a curved stem and a thistle head in base mix. Paint two S-curves midway up the stem and create points on the leaves. Also paint sepals at the base of the thistle head using S- and C-curves. Drop in Prussian Blue at the base of the thistle head and the leaves. Allow to blend. Use the wet paint in the thistle head to push little C-curve filaments into a halo around the head. Allow to dry fully.

2.
Paint an outer layer of filaments in Prussian Blue with your size 0 brush. Clean the brush off and with the wetness of the brush, paint further filaments. The blue from the outer layer will blend into the middle.

6.
At the base of the thistle head, paint a skirt of filaments in Prussian Blue with your size 0 brush. Clean off your brush and with the same wet brush, paint and blend filaments upward to blend with the strokes overhead and create a fully covered thistle head.

7.
To finish off, add some small sepals in Prussian Blue with your size 0 brush, as well as painting some lines in dark mix at the the top of the stem and at the midway point with the leaves with your size ⅜ brush.

MUSCARI

As a child, I was convinced each little muscari that popped up in spring was a bunch of grapes belonging to a doll's house.

WHAT YOU WILL NEED

Brushes
Size 0
Size 2

Colors

 Sap Green

 Permanent Rose

 Cadmium Yellow

 Prussian Blue

 Base Mix
Sap Green and
Cadmium Yellow

 Purple Mix
Prussian Blue and
Permanent Rose

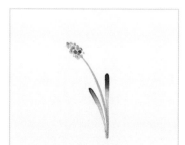

IN MINIATURE
With a size 0 brush, paint a curved stem and two leaves in base mix. Add Sap Green to the tip of each leaf while still wet. Paint your buds in a cluster around the tip of the stem. As you progress down, change color from diluted Prussian Blue to purple mix.

1

1.
Draw a faint pencil stem that is long and curved. With a size 2 brush, paint a stem in wet base mix and two long, thin C-curve leaves. Drop some concentrated Sap Green onto the tips of the leaves and allow it to blend downward.

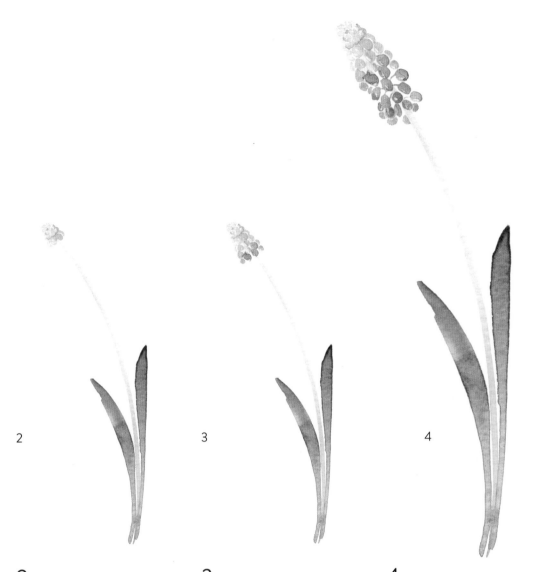

2.

Muscari buds are arranged like bricks, sitting snugly in between the previous layer's spaces. Starting at the top of the stem with very diluted Prussian Blue on a size 0 brush, paint approximately four rows of buds, with each row getting a little larger as you progress down. Allow for a little white space between the buds to get a sense of definition.

3.

Add a little purple mix to your Prussian Blue as your buds grow in size and become more spaced out.

4.

For the lowest rows, work in a more concentrated Prussian Blue and purple mix. These buds should be so spaced out that you should be able to paint little visible stems holding each bud, in the same color.

SNAPDRAGON

Apparently the snapdragon is so named because of its flower's resemblance to a dragon that opens and closes its mouth when it is squeezed.

I have included two purple mixes, both using Permanent Rose and French Ultramarine, where I have played a bit with the ratios. While there are some fantastic ready-mixed purples available, I want to show how you can create different mixes from a limited palette.

I have created extra illustrations to demonstrate how to use your S- and C-curves to create the variations of buds for each step. This exercise is all about using negative space – leaving unpainted gaps in between the buds and not being afraid of blank space.

WHAT YOU WILL NEED

Brushes
Size 2
Size 4

Colors

 French Ultramarine

 Sap Green

 Permanent Rose

 Cadmium Yellow

 Base Mix
Sap Green and
Cadmium Yellow

 Purple Mix
One part French
Ultramarine and two
parts Permanent Rose

 Pink Mix
Four parts Permanent
Rose and one part
French Ultramarine

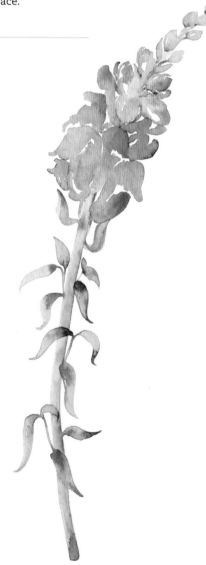

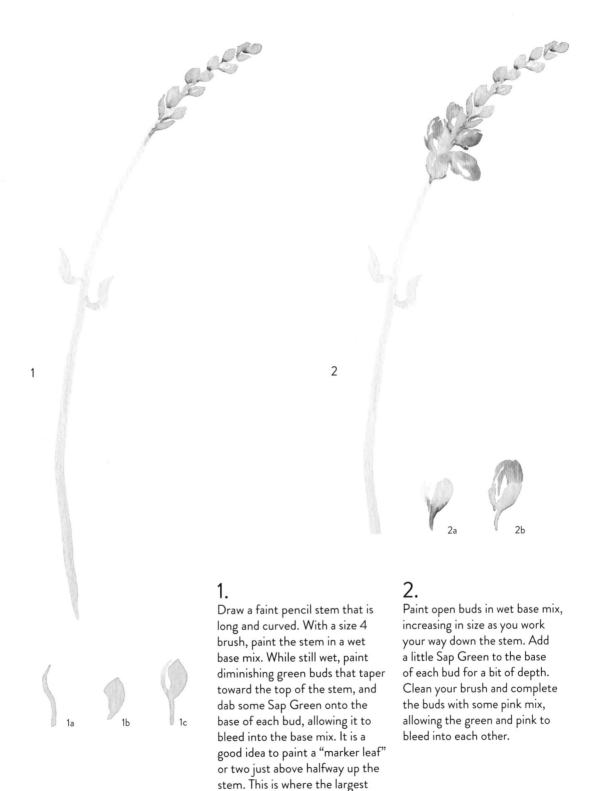

1

2

2a 2b

1a 1b 1c

1.

Draw a faint pencil stem that is long and curved. With a size 4 brush, paint the stem in a wet base mix. While still wet, paint diminishing green buds that taper toward the top of the stem, and dab some Sap Green onto the base of each bud, allowing it to bleed into the base mix. It is a good idea to paint a "marker leaf" or two just above halfway up the stem. This is where the largest flowers will sit.

2.

Paint open buds in wet base mix, increasing in size as you work your way down the stem. Add a little Sap Green to the base of each bud for a bit of depth. Clean your brush and complete the buds with some pink mix, allowing the green and pink to bleed into each other.

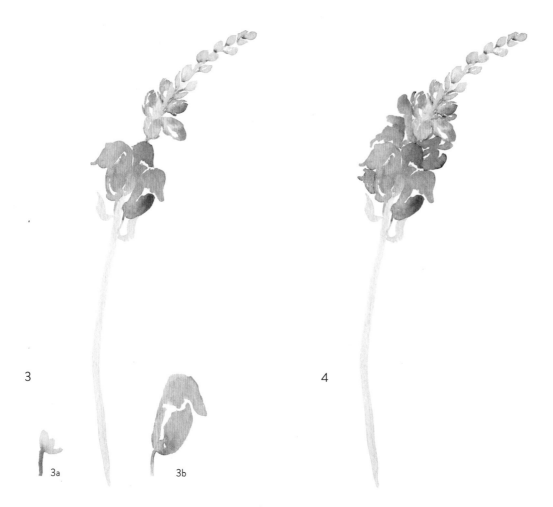

3

3a 3b

4

3.

Move down to your marker leaves to paint the largest flowers. Start with an open bud in base mix. Paint two strokes of pink mix petals with an overhanging flap. Paint a flowering bud either side of the stem and one in between, if necessary to fill space. Drop some purple mix into the wet pink mix and allow it to blend. If you are using enough water, the color will slowly blend successfully on its own. Allow to dry fully.

4.

Now fill in the space between the bottom blooms and the buds above. Use a combination of C-curves in pink mix and purple mix to depict numerous opening snapdragon flowers. Remember to leave gaps of unpainted white space so that you don't end up with a pinky-purple blob.

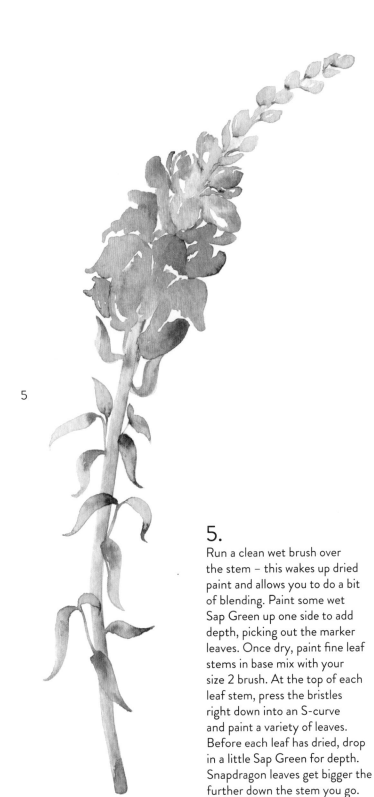

5

1 2

IN MINIATURE

1.
Paint a stem in wet base mix with the tip of your size 2 brush. While still wet, paint a cluster of dabs in wet purple mix around the midpoint of the stem.

2.
Allow the brush to gradually run out of color and only add more water as you work your way up the stem, tapering to a point. Paint C-curve leaves in wet Sap Green down the remaining bare stem.

5.

Run a clean wet brush over the stem – this wakes up dried paint and allows you to do a bit of blending. Paint some wet Sap Green up one side to add depth, picking out the marker leaves. Once dry, paint fine leaf stems in base mix with your size 2 brush. At the top of each leaf stem, press the bristles right down into an S-curve and paint a variety of leaves. Before each leaf has dried, drop in a little Sap Green for depth. Snapdragon leaves get bigger the further down the stem you go.

FREESIA

The freesia is an elegant stem that pops up out of a bouquet or arrangement with languid ease. When creating your sepals and buds, remember it is what you leave unpainted – the negative space – that really gives character and depth to the flower.

WHAT YOU WILL NEED

Brushes
Size 4
Size 8

Colors

Sap Green

Cadmium Orange

Cadmium Yellow

Stem Mix
Sap Green and
Cadmium Yellow

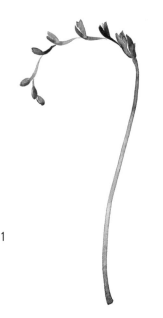

1

2

1.
Draw a faint pencil stem, as if you were drawing a question mark. With your size 4 brush, paint the upright length in wet stem mix, and drop in a little wet Sap Green at the top and bottom. For the curl, paint a series of shrinking S-curves in Sap Green and add an extra stroke to the upturned end of each to create a green bud sepal. Allow to dry.

2.
To create the largest freesia flower, paint wet Cadmium Yellow S-curves that start with the tip of the size 8 brush at the base of the flower and spread into broad strokes. A cluster of four will create a flower on the cusp of opening. While still wet, sweep a little wet Cadmium Orange up the sides and along the tops of the petals and allow it to blend down. If the yellow is wet enough, it will blend of its own accord.

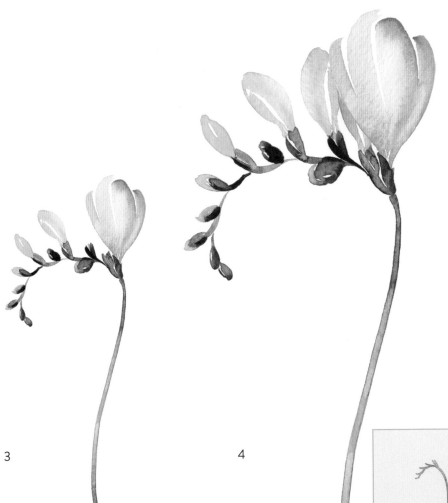

3

4

It is likely that the next few buds on the stem will overlap with the main flower, so leave those for now. Paint shrinking buds with two mirrored S-curves onto the remaining sepals (omitting the smallest few on the end of the stem). Paint your larger buds in Cadmium Yellow and add a little Sap Green to the mix as the buds get smaller.

3.
With your size 4 brush, sweep some concentrated Sap Green up the curved edges of the sepals to add depth. Add a few extra sepals and green buds.

4.
Now the main flower is dry, paint in the extra buds behind it with a mixture of Cadmium Yellow and Cadmium Orange.

1 2

IN MINIATURE

1.
With a size 0 brush, paint a stem in stem mix. As you reach the top, bring it over in a curl with a series of shrinking S-curves. Allow to dry.

2.
Paint buds and flowers in wet Cadmium Yellow, dropping in a little Cadmium Orange while wet. Dab some extra buds in stem mix in bewteen the flowers.

LIMONIUM

The key to painting this sturdy little spray flower is to work in sections, completing each stage fully before moving down the stem to the next. There is wonderful repetition in the design of this stem as each small branch is a clone of its bigger counterpart.

WHAT YOU WILL NEED

Brush
Size 0

Colors

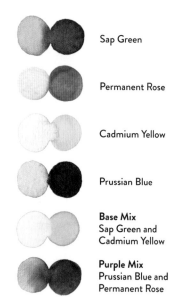

Sap Green

Permanent Rose

Cadmium Yellow

Prussian Blue

Base Mix
Sap Green and
Cadmium Yellow

Purple Mix
Prussian Blue and
Permanent Rose

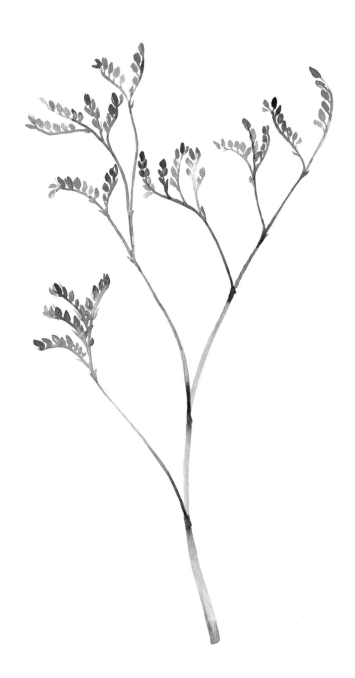

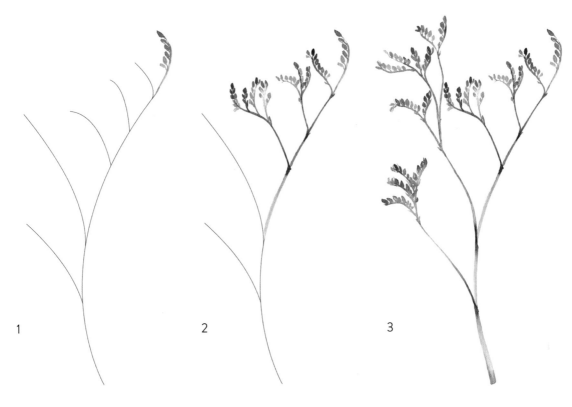

1

2

3

1.

First draw an S-curve stem in faint pencil, then draw a series of branches on just one side that curve up and away from the main stem, getting smaller as they reach the top. Focusing on just the top section, paint a thin stem in wet base mix with a size 0 brush. With wet purple mix, press down the full thickness of the bristles to create a purple bud. As you lift the brush, allow the tip to remain touching the paper, and move the tip downward to create a fine stem that connects with the wet main stem, blending purple into green. Paint buds along the main stem, ensuring that each mini bud stem is angled downward.

2.

Work your way down the main stem and repeat step 1. Create smaller branches and buds off each branch. Just remember the rule that each mini stem and branch is a miniature version of the limonium as a whole. At the base of each new branch growth, add a tiny Sap Green leaf.

3.

Repeat all the way down the stem, making the main stem thicker as it goes down.

IN MINIATURE
Using the tip of a size 0 brush, paint a curved stem in base mix with branches that have their own curved mini branches. Add dabs of purple mix along each mini branch.

ASTRANTIA

A mix of green and violet shouldn't work, but it does. Be sure to mix the astrantia mix with plenty of water to get the antique, dusky mauve that works for the stem as well as the petals. You can drop additional dabs of violet into the petal mix to up the vibrancy.

WHAT YOU WILL NEED

Brushes
Size 0
Size 2

Colors

 Cobalt Violet

 French Ultramarine

 Sap Green

 Permanent Rose

 Purple Mix
French Ultramarine and Permanent Rose

 Astrantia Mix
Sap Green and Cobalt Violet

1

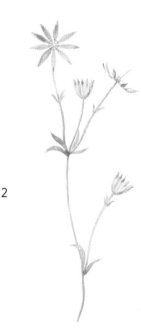

2

1.

Draw a faint forked stem in pencil that is long and curved. With a size 2 brush, paint the stem in astrantia mix leaving a few centimeters of pencil at the top. For the face-on flower, draw a faint pencil circle at the end of your pencil stem, and for the side-on flower, draw a U a few centimeters from the end of the pencil line which will be the base of the flower. Add clusters of S-curve leaves at stem intersections and smaller clusters at midway points on the branches.

2.

For the face-on flower, always start your petals from the center working outward. With a very diluted astrantia mix, paint tapered line petals. For the open side-on flower, paint a flattened fan of C-curve petals emanating from the U. Finally, for your closed flowers, paint a tighter cluster of C-curve petals. The closed flowers are now done.

3.

Allow the paint to dry. Repeat step 2 in the gaps between the petals of the face-on and side-on flowers and you will get a delicate overlap. Allow to dry fully.

4.

To create the face-on flower's stamens, we go against the usual rules and start with the darkest color first. Paint a halo of tiny anthers in concentrated purple mix with your size 0 brush. Scatter them at random, making sure they form a rough circle. Allow to dry fully.

5.

Dab Sap Green under each purple anther and complete the face-on flower with fine filaments in purple mix emanating from the center. For the side-on flower, we can work a little more logically: start with a fan of purple mix filaments emanating from the center, then add Sap Green dabs to the top of each line and finish them with a purple mix anther.

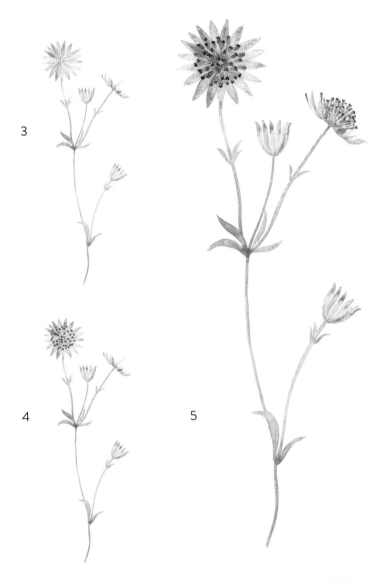

3

4

5

IN MINIATURE

1.
Paint a stem and leaves in wet astrantia mix with a size 0 brush.

2.
Paint a first round of petals in astrantia mix for both flowers. Allow to fully dry.

3.
Add diluted Sap Green to the center of the face-on flower, and as a dome for the side-on flower. Finish with purple mix anthers, a few little filaments and a few accents to the petal edges to add depth.

CRASPEDIA

There I was, compiling a list of flowers that would be perfect to paint, thinking that the humble little craspedia would be quick and easy – it turned out to be one of my longest trial projects, purely because there were so many ways it could be painted. I've done the hard work so you don't have to!

WHAT YOU WILL NEED

Brush
Size 2

Colors

 Prussian Blue

 Cadmium Yellow

 Green Gold

 Burnt Sienna

 Shadow Mix
Prussian Blue
and Burnt Sienna

IN MINIATURE
With a size 0 brush, paint an oval in Cadmium Yellow. Paint a fine line in shadow mix, allowing it to touch the wet Cadmium Yellow head and blend a little. If your painted stem dries out, leaving you with a scratchy line, that is all for the better: craspedia are often dried and this dry, uneven line depicts their stems brilliantly.

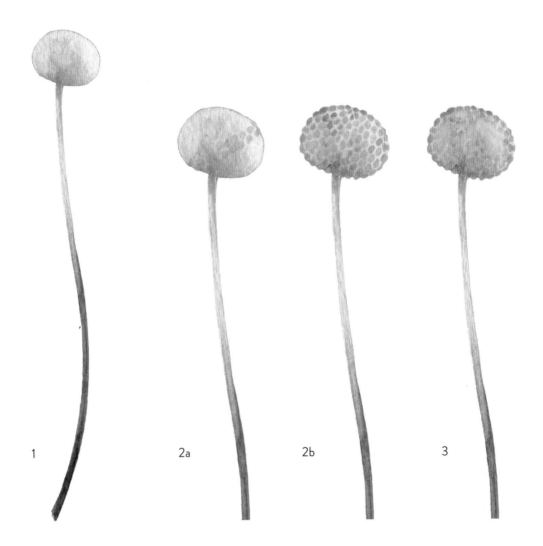

1 2a 2b 3

1.
Draw a faint pencil stem that is long and curved with an oval head. Paint the stem in diluted Burnt Sienna with a size 2 brush. While still wet, gradually add shadow mix down the stem until it is seriously dark at the bottom. Paint the oval in diluted Green Gold and dab some diluted shadow mix into the base of the oval head. Allow to dry fully.

2.
Mix a concentrated Cadmium Yellow. The craspedia rosettes form a Fibonacci sequence, which would be extremely time consuming to re-create. Instead, paint diagonal lines of dots, flattening any dots at the edges to give the sense they are continuing over the other side of the oval head. This helps achieve the roundness of the seed head and gives a sense of the formation of the rosettes. Continue until you've filled the whole oval.

3.
To add a little more character and roundness to the seed head, take a clean, wet size 2 brush and make a few C-curves, allowing some of the yellow dots to blend and become less perfect. Don't overdo it or you'll end up with a yellow blob.

CHERRY BLOSSOM

In Japan, the cherry blossom's fleeting lifespan – just two weeks of bloom – is seen as a symbol for the fragility of life. I am consistently drawn to the contrast of the pale pink blossoms and the impossibly dark stem. A mix of Prussian Blue and Cadmium Red captures the warm darkness of cherry wood perfectly.

WHAT YOU WILL NEED

Brushes
Size 0
Size 2
Size 4

Colors

 Prussian Blue

 Permanent Rose

 Cadmium Red

 Green Gold

 Flower Mix
Permanent Rose
and Prussian Blue

 Stem Mix
Cadmium Red
and Prussian Blue

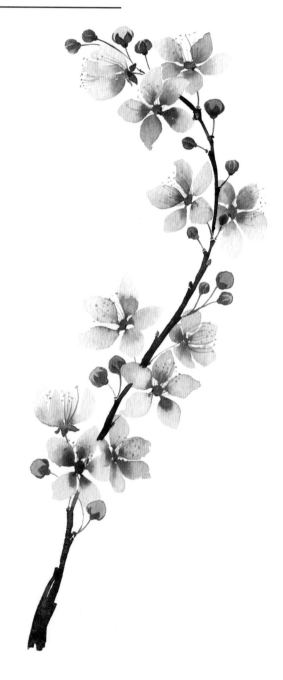

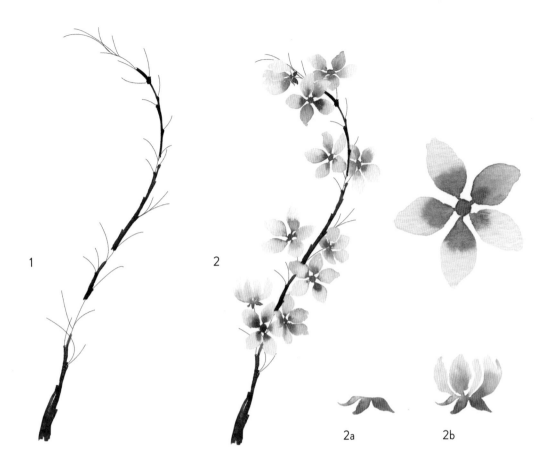

1

2

2a

2b

1.

A cherry blossom stem is gnarly and covered with buds. Draw a faint pencil stem and numerous clusters of short branches. Your open flowers may well overlap the stem, so plan your flower placement and leave any overlapped sections of the stem unpainted. Paint the stem with plenty of notches and angles in stem mix with a size 2 brush.

2.

Open flowers start with a very wet dot of flower mix. Touch the wet center with the tip of a clean, wet size 4 brush and paint a fat oval petal. The color will draw out of the center into the petal. Don't be tempted to coax it out and overblend it with your brush, it will happen on its own with a wet enough petal. Paint five spaced out petals.

For side-on flowers, start by painting sepals in flower mix and then paint C-curves with a clean, wet brush (see 2a and 2b).

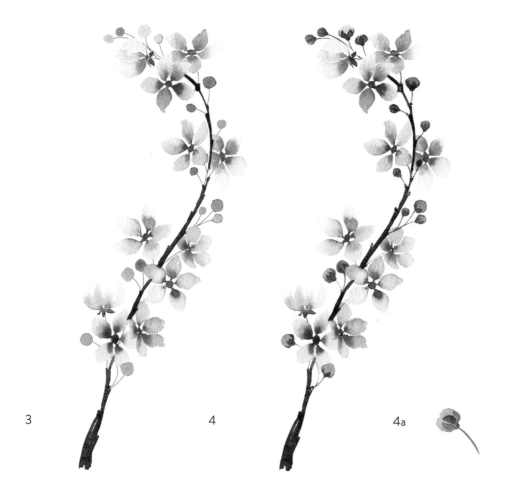

3

4

4a

3.
Paint blobs of diluted Permanent Rose for buds on the ends of the remaining empty branches. Allow to dry fully.

4.
With the tip of your size 0 brush, paint delicate stems for the buds in flower mix, and C-curve sepals closed up around each bud. Paint a delicate stem to each flower, where visible. Allow to dry fully.

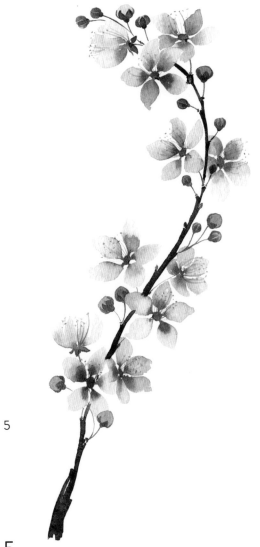

5

5.
Paint stamens emanating from
each flower center with the tip
of your size 0 brush in diluted
Permanent Rose. Top them with
tiny dots of Green Gold.

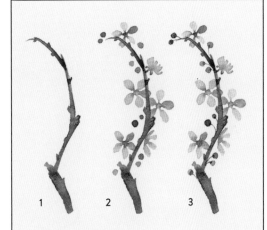

1 2 3

IN MINIATURE

1.
Paint a gnarly stem in stem mix
with a size 0 brush.

2.
Add floating flowers and buds in
Permanent Rose.

3.
Paint curved stems
for the buds in stem mix.

HYPERICUM BERRIES

These particular berries have a beautiful blush color that blends into the warm green of the stem. This plant is full of subtle color – crying out to be painted in watercolor – and is a brilliant supporting act in any bouquet.

When painting the berries and stem, make sure all your colors are extremely diluted.

WHAT YOU WILL NEED

Brushes
Size 2
Size 8

Colors

 Prussian Blue

 Sap Green

 Permanent Rose

 Cadmium Red

 Cadmium Orange

 Cadmium Yellow

 Green Gold

 Burnt Sienna

 Base Mix
Sap Green and
Cadmium Yellow

 Blush Mix
One part Cadmium
Orange and three parts
Permanent Rose

 Dark Mix
Prussian Blue and
Permanent Rose

1.

Draw a faint pencil stem with forked branches to carry clusters of two or three berries at a time. Working to complete each berry before starting the next, paint the top dome of a berry in diluted blush mix with a size 2 brush, clean your brush and complete the base of the berry with diluted base mix. Allow the two colors to blend on their own and leave a few unpainted spaces on the berries which will look like light bouncing off of the glossy surface. While still wet, drop a tiny dab of Permanent Rose at the top of each berry. Allow to dry fully.

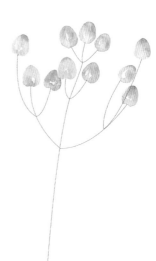

1

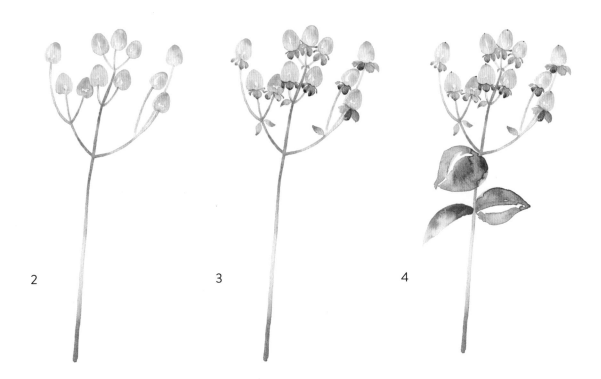

2

3

4

2.
With your size 2 brush, paint the main stem and branches with diluted base mix. Drop in Sap Green at the base, Burnt Sienna and Cadmium Red at the main cross section of branches, and Green Gold further up at the smaller cross sections. Allow to dry fully.

3.
With your size 2 brush, paint approximately four sepals in wet Sap Green at the base of each berry. Place a dab of concentrated Sap Green at the outer tip of a few leaves to add a little depth. Paint a few small leaves at the branch intersections using the same technique. Allow to dry fully.

4.
Place a small dot of concentrated dark mix at the top of each berry. With your size 8 brush, paint a few broad, smooth-edged leaves in wet Sap Green at parallel points on the stem using S-curves. Drop a little bit of strong, wet Sap Green and Prussian Blue at the base of each leaf to intensify the dark color.

1

2

IN MINIATURE

1.
Paint a stem and branches in Green Gold with your size 0 brush. Paint blush mix berries at the top of each branch, making sure you get the shape of the berry, even though it is just in miniature.

2.
Add Sap Green sepals and broad stem leaves. Paint diluted Burnt Sienna down the branches to add depth. Place a small dot of concentrated dark mix at the top of each berry.

FOLIAGE

FERNS

With over 20,000 species to choose from, I would be doing ferns a disservice by focusing on just one. They are wonderful things to doodle – a botanist would struggle to identify many of my fern paintings so let your imagination run wild. Looking closely at a fern's pattern and structure is like falling down a rabbit hole – you can get lost in the repetitive detail. My approach captures the essence of the fern in a loose watercolor style, rather than spending months working on a single branch's mesmerizing detail.

This section covers a number of fern projects that all follow a similar process. I have listed my color palette when painting any fern and have also made suggestions of mixes for each individual painting.

Ferns are a brilliant starter project: in spite of looking intricate and complicated, these projects involve a few simple steps and a lot of repetition. Put a some good podcast on and you're all set. All of these projects can be recreated in miniature simply by following the main steps but using a size 0 brush.

WHAT YOU WILL NEED

Brushes
Size 0
Size 2

Colors

Cadmium Yellow

Sap Green

Burnt Sienna

Prussian Blue

Branch Mix
Prussian Blue
and Burnt Sienna

Dark Leaf Mix
Sap Green and
Prussian Blue

Leaf Mix
Sap Green and
Cadmium Yellow

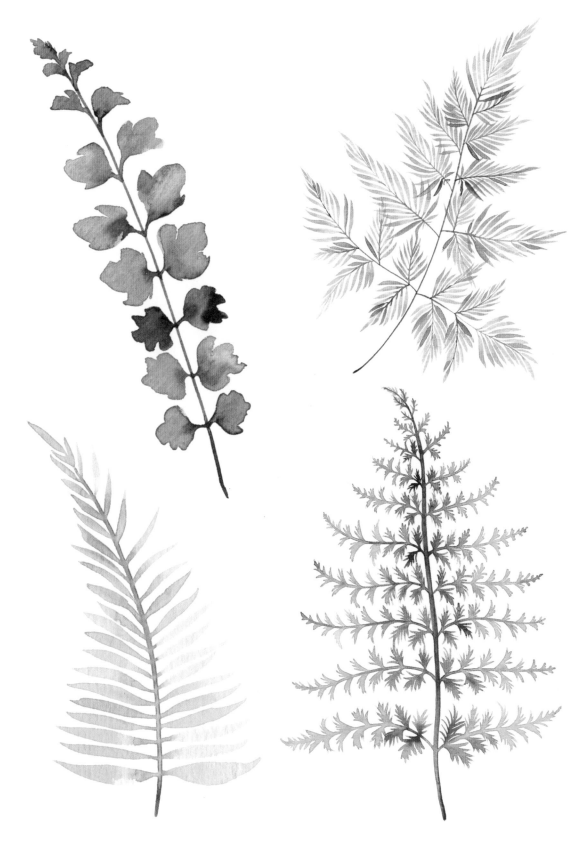

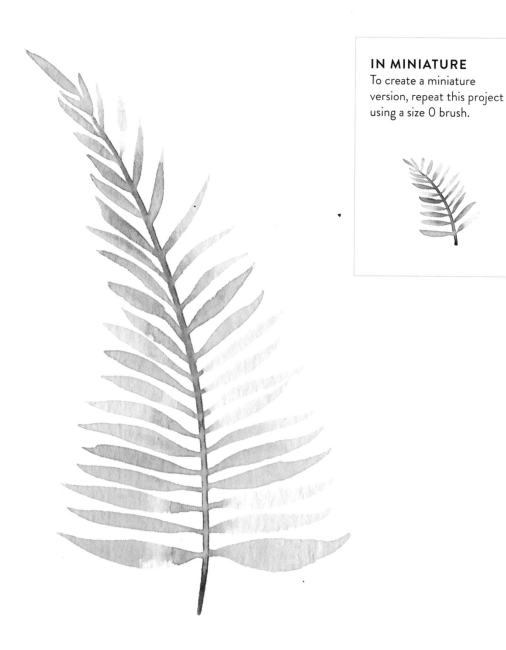

IN MINIATURE
To create a miniature
version, repeat this project
using a size 0 brush.

INSPIRED BY GLADE FERN

Draw a faint curved pencil stem and paint it in wet Sap Green with
a size 2 brush. Paint pairs of parallel C-curves for leaves in leaf mix,
getting increasingly smaller and more angled toward the tip as you
reach the top. The Sap Green from the stem should blend out into
each leaf.

INSPIRED BY MAIDENHAIR FERN

Using dark leaf mix, once you have drawn a slightly curved pencil stem, paint a fine line with your size 0 brush. The leaves begin in parallel pairs at the base. For a basic leaf shape, paint two mirrored S-curves with a size 2 brush, then complete the leaf with a central dome created with two mirrored C-curves. Play around with that basic design to create varied shapes. The leaves get increasingly smaller and more angled toward the tip of the stem, and begin to grow alternately right at the tip.

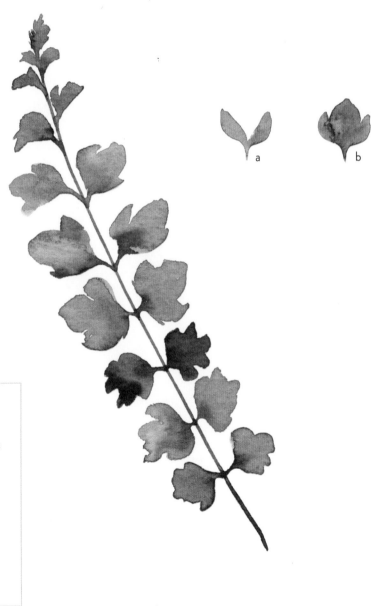

a

b

IN MINIATURE
To create a miniature version, repeat this project using a size 0 brush.

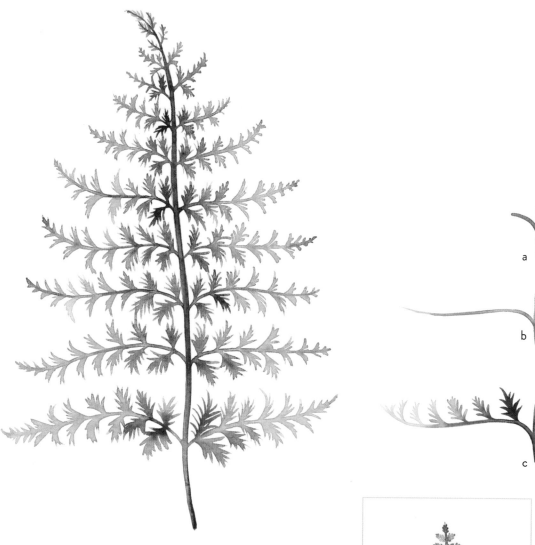

a

b

c

INSPIRED BY PAINTED FERN

Draw a faint curved pencil stem and paint it with wet Sap Green and a size 2 brush. Work to complete one branch at a time, as this project needs wet color to create good blends. Paint the beginnings of a Sap Green branch, then quickly clean your brush and paint the remainder of the branch in wet Cadmium Yellow. Starting from the green end of the branch, paint a Sap Green mini branch: paint a thin C-curve then add smaller C-curves up each side. Paint approximately two pairs in Sap Green and clean your brush off. With your wet brush, paint the rest using the color that will blend up from the wet branch. Shrink your mini branches until they are simply C-curves tapering to a point.

IN MINIATURE

To create a miniature version, paint a central Sap Green stem and paint the branches and segments in Cadmium Yellow using a size 0 brush.

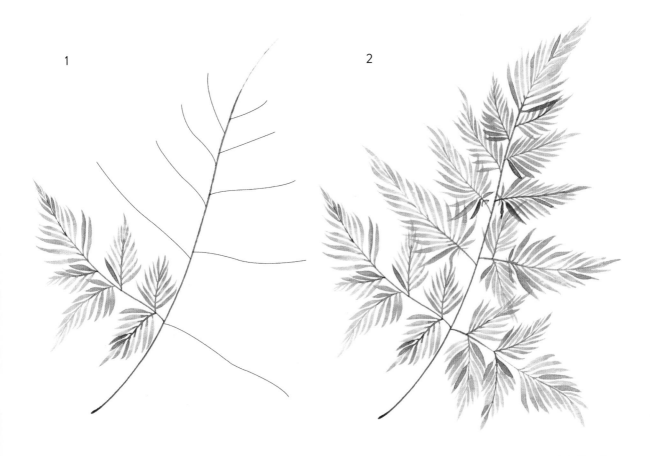

INSPIRED BY SILVER FERN

1.

Draw a slightly curved pencil stem and long, alternating branches. The leaves are long so space your branches widely (but if leaves sometimes overlap, that is fine). Using branch mix, paint a fine line stem with your size 0 brush. Work to complete one branch at a time: paint a segment of branch in branch mix and then paint parallel tapered strokes that get increasingly smaller and more angled toward the tip in diluted Sap Green. There will be a little blend from the segment branch to the leaves.

2.

Complete the fern branch by branch. Each branch end is a miniature fern in itself, and as your branches get shorter toward the top, you will just need to paint a single mini fern each time.

IN MINIATURE

To create a miniature version, paint a Burnt Sienna stem and alternating branches. Paint diluted Sap Green tapered lines in a fern formation on each branch. Use a size 0 brush for all the steps.

THLASPI

I have chosen to put thlaspi in the foliage section, although it does boast a tiny flower at the tip. I love this plant for its eccentric, twirling stems that reach out of an arrangement in all directions.

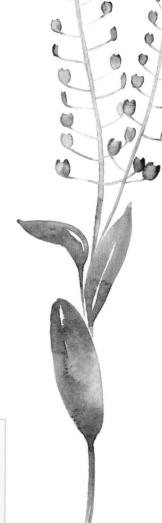

WHAT YOU WILL NEED

Brushes
Size 0
Size 8

Colors

 Sap Green

 Cadmium Yellow

 Base Mix
Sap Green and
Cadmium Yellow

IN MINIATURE
With a size 0 brush, paint a base mix stem with leaves at the base. Paint seed branches in Sap Green and sweep a tiny bit along the edge of the leaves. Allow to blend and dry.

1.

Draw a faint pencil stem that forks into two. Starting at the base, paint a few leaves that grow smaller as you go up the stem, using mirroring S- and C-curves in base mix with your size 8 brush. Sweep a little Sap Green up the outer edges for a little more depth.

2.

With your size 0 brush, paint seed branches in base mix at alternate points up both stems, shrinking as they ascend into a clustered dome at the top. To do this, paint fine, curling branches out from the stem and press your brush onto the page to create a seed head blob. Allow to dry for 30 seconds (I usually paint batches of six seed branches for perfect drying time), then add two mirrored C-curves of Sap Green to the seed blob and allow to blend.

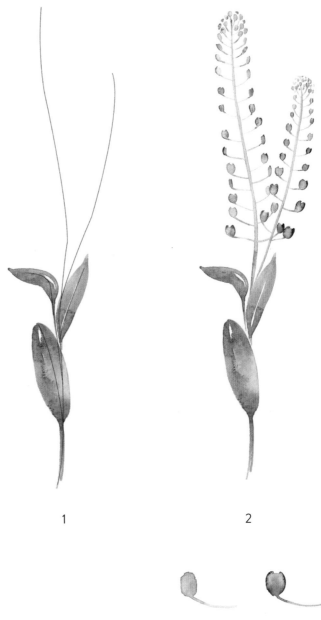

1

2

2a 2b

EUCALYPTUS

Dusky and muted, pale and interesting, eucalyptus is the elegant superstar of greenery's resurgence in bouquets. It has been elevated from best supporting act in an arrangement to the cornerstone of many a wedding color palette. It is so easy to paint, and it is wildly satisfying to overlap the diluted petals.

We will be working in extremely diluted blends, painting a first layer of leaves, letting them fully dry and then overlapping them with a second batch. Although eucalyptus leaves are not transparent, this painting style brings out the dusty delicacy of the gray-green leaves.

I had always assumed eucalyptus leaves were perfectly round, like lily pads. On closer inspection, they look more like the spade in a pack of cards.

WHAT YOU WILL NEED

Brushes
Size 2
Size 8

Colors

 Sap Green

 Burnt Sienna

 Prussian Blue

 Stem Mix
Prussian Blue
and Burnt Sienna

 Leaf Mix
Sap Green,
Burnt Sienna
and Prussian Blue

IN MINIATURE
Using a size 0 brush for the whole mini project, paint a forked stem in stem mix. Allow to partially dry. Add rounded leaves up the stem in leaf mix in parallel pairs. As they shrink you can paint squashed kidney bean shapes to achieve the parallel leaves.

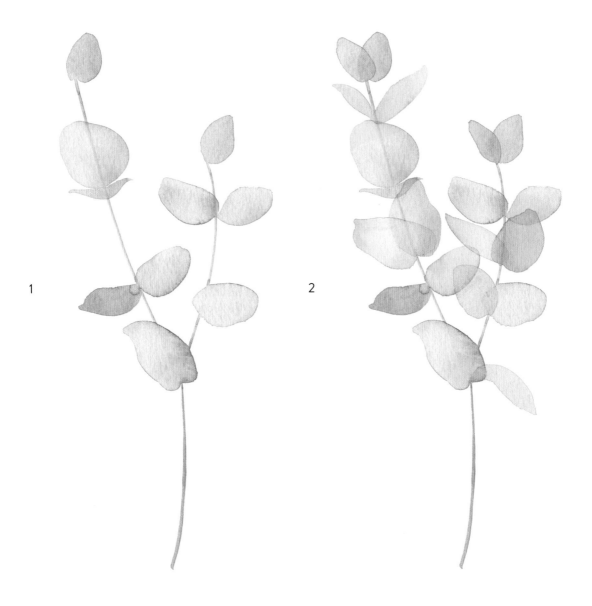

1
2

1.

Draw a forked stem in faint pencil. To ensure a smooth blend from leaf to stem, work in sections. Starting at the bottom of the stem, paint over your line in diluted stem mix with the tip of your size 2 brush, up to the intersection. Paint your first leaf at the intersection in leaf mix with your size 8 brush. Use plenty of water – as it dries the color will swell, creating crisp edges with a translucent center. Continue up both stems, painting leaves at different angles and spaced out enough that a second batch of leaves will be able to fit in between with a little overlap. On the whole, eucalyptus leaves grow at parallel points, shrinking in size as they reach the tip.

2.

Once fully dry, add leaves in the gaps in diluted leaf mix, allowing for overlaps.

BEECH LEAVES

A single branch of beech leaves offers a full spectrum of foliage color.

The three steps to paint each leaf must be done while the paint is very wet to ensure a good blend. Be liberal with your amount of water, and try to work as quickly as possible. The fuzzy, uneven blend lines that we sometimes strive to avoid (caused by using copious amounts of water) come into their own in this project, mimicking a leaf changing through the seasons.

WHAT YOU WILL NEED

Brushes
Size 0
Size 8

Colors

 Sap Green

 Prussian Blue

 Burnt Sienna

 Cadmium Orange

 Cadmium Yellow

 Dark Stem Mix
Prussian Blue
and Burnt Sienna

 Base Mix
Sap Green and
Cadmium Yellow

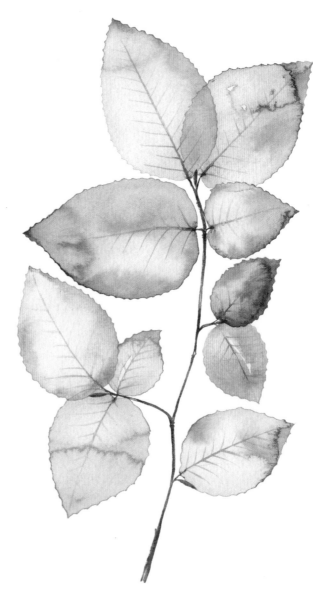

1.

Draw a faint pencil stem and a batch of short branches. From those branches, add faint pencil lines that will be the central lines of the leaves. Having these in place is useful when shaping your leaves. To paint the leaves, I have tried out a range of color blends from the suggested palette but I will describe a yellow and green leaf here. Paint two mirrored S-curves in wet Cadmium Yellow with your size 8 brush. Fill in the shape with more water. Pick up some concentrated Sap Green and use the tip of the brush to paint an inverted scalloped edge around the leaf, making sure you are touching the wet yellow so that the two colors blend. Paint as many leaves as you can without them overlapping each other, using different colors from the palette. Allow to dry fully.

2.

Once the first layer is dry, fill the remaining gaps with leaves.

3.

With your size 0 brush, paint the stem in dark stem mix, reaching to the base of each leaf. Add a small leaf bud at the junction of some branches.

4.

With diluted dark stem mix, paint a central line up the leaf. You want it to have faded out before reaching the leaf tip. Dab a little concentrated dark stem mix at the base of the leaf to intensify the color and allow to blend up the central vein. Adding no more color, but a little more water to your brush, paint lines (usually parallel but do check the real thing if you can as it varies)

emanating from the central line, angled upward. Again, these lines want to fade to nothing before getting halfway to the leaf's edge.

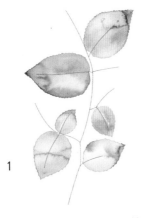

1a 1b 1c

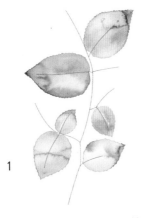

1

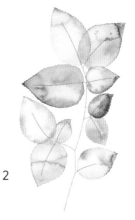

2

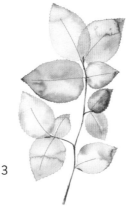

3

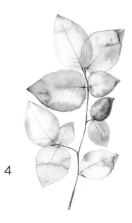

4

IN MINIATURE

This project works in exactly the same way in miniature, just use a size 0 brush for everything.

BIRCH LEAVES

The birch project offers a different approach to painting loose watercolor leaves from that of the beech. Here it is all about the brushstrokes and the unpainted space creating the leaf shape.

WHAT YOU WILL NEED

Brushes
Size 0
Size 8

Colors

 Sap Green

 Prussian Blue

 Burnt Sienna

 Dark Stem Mix
Prussian Blue
and Burnt Sienna

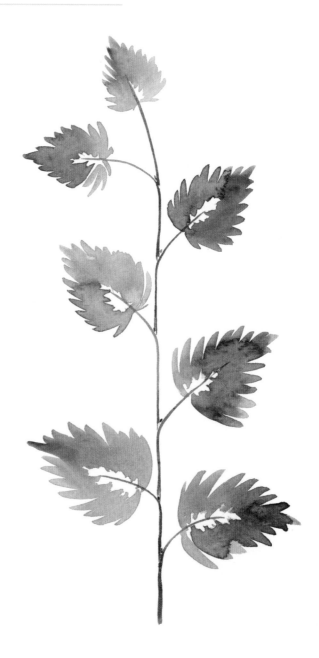

IN MINIATURE
This project works in exactly the
same way in miniature, just use a
size 0 brush for everything.

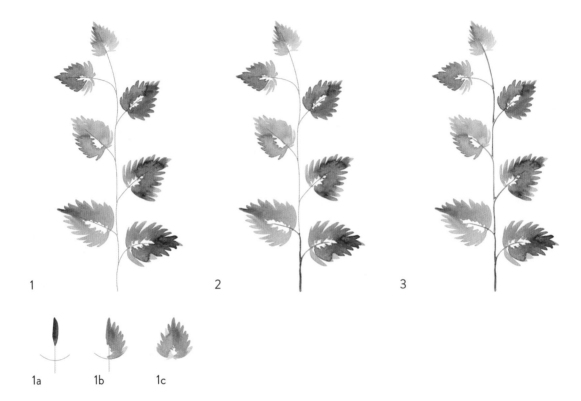

1

2

3

1a 1b 1c

1.

Draw a faint pencil stem and
a batch of short, alternating
branches. Starting at the
uppermost point, with your size
8 brush, paint a wet Sap Green
leaf following steps 1a, 1b and 1c:
a central tapered line, followed
by a fan of tapered line strokes
down one side, gathering into
the central base. Repeat down
the other side. Add leaves to
each branch.

2.

With your size 0 brush, paint
the bottom quarter of the stem
in sections, using dark stem mix.
Add a leaf bud at the junction of
some branches.

3.

Complete the rest of the
stem using Burnt Sienna.

PALMS

I have been happily caught up in the house plant revolution, and now palm leaves have made their way into bouquets and arrangements. This section covers three particularly popular palm leaves.

WHAT YOU WILL NEED

Brushes
Size 0
Size 2
Size 8

Colors

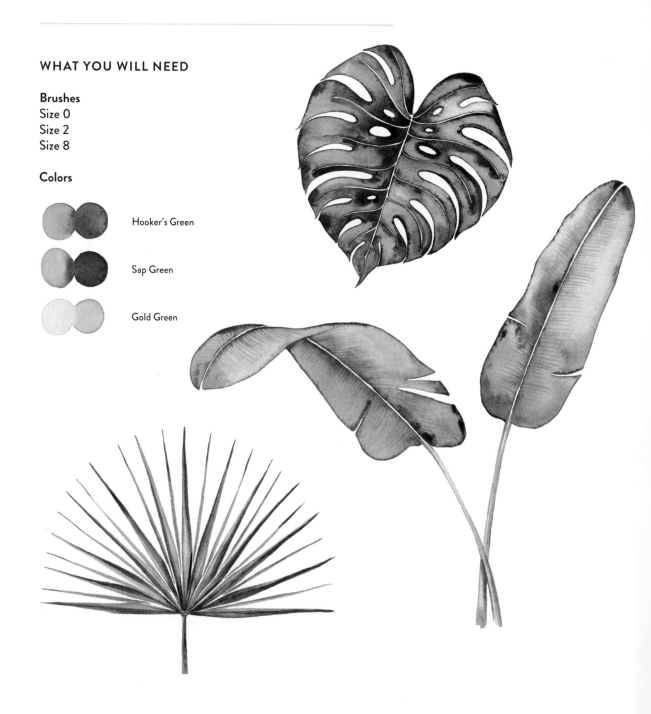

Hooker's Green

Sap Green

Gold Green

BANANA PALM LEAF

1.

It is worth faintly sketching out your palm leaves, particularly if painting a cluster. Start with your central stem line and then build the leaves out from there. Banana palms can have horizontal slits up and down the leaves, formed by the broken ridges on the palms, so mark these out, too.

2.

With your size 8 brush, paint the leaf sections in wet Green Gold, making sure to leave a fine unpainted line up the center. While still wet, edge the wet shape with concentrated Hooker's Green and allow it to blend in.

3.

For each stem, paint two parallel lines down from the leaf base in Green Gold with your size 0 brush. Blend the lines toward the bottom and add some Hooker's Green.

4.

With a size 0 brush and diluted Hooker's Green, paint ridges emanating from the central leaf vein that follows the shape of the leaf. The cuts in the leaf slits will be helpful to guide which direction your lines should go in.

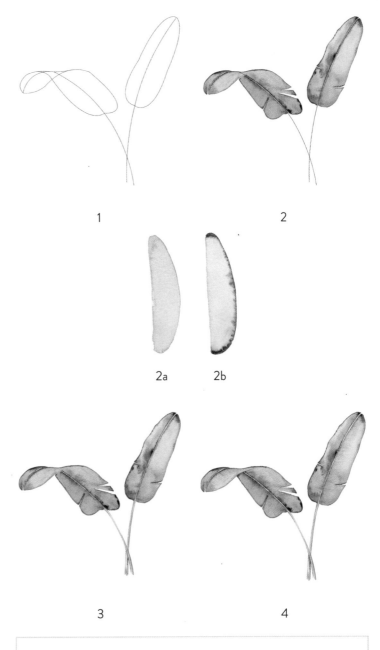

1

2

2a 2b

3 4

IN MINIATURE

Do all this with a size 0 brush. You can paint two mirrored, elongated C-curves in Green Gold to create the leaf shape. Outline them with Hooker's Green and allow to blend. Add a Hooker's Green stem. Once fully dry, paint diluted Hooker's Green ridges out from the leaf's center.

IN MINIATURE

Use a mini version of the pencil guide from the main project. Paint a fan of palm leaves and a central stem in diluted Hooker's Green. Allow to dry before painting a second, smaller fan of lines in a more concentrated Hooker's Green.

PALMETTO FAN

1.

Draw an even-length cross and then a semicircle from either side with the vertical line intersecting the center of the curve. Using your size 0 brush, starting from the center point, paint a fan of extended tapered lines in Green Gold, and sweep a line of Hooker's Green up one side of each line. Each leaf should just overlap the pencil semicircle. Allow to fully dry.

2.

In the gaps, paint even finer palm leaf lines in Hooker's Green. Allow to dry.

3.

Use concentrated Hooker's Green to add depth to each leaf by painting extra shadow lines along each leaf. Add a stem down the central vertical line.

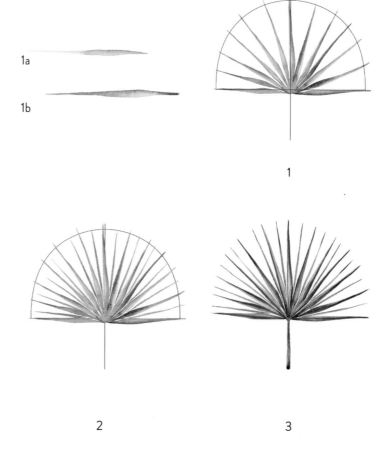

1a

1b

1

2

3

IN MINIATURE

1.
Draw a fat, squat heart shape and paint the outline of one side of the leaf.

2.
Fill in the leaf with Hooker's Green and then outline it with concentrated Sap Green. Repeat on the other side, maintaining the unpainted center.

3.
To paint a leaf from the side, just paint one side of the leaf, or make one side a little squashed so that it looks angled. Add straight stems emanating from the top center of the leaf.

1
2
3

MONSTERA DELICIOSA (OR CHEESE PLANT)

1.
This is a beautiful leaf that works best when you plan it out in advance. Draw a fine pencil sketch of the leaf first. The shape is symmetrical but the pattern is not.

2.
Work in fairly small sections so that the paint doesn't dry too fast. Paint the sections down one side in wet, diluted Hooker's Green with a size 2 brush. While still wet, outline them with a size 0 brush loaded with concentrated Sap Green.

3.
Complete the other side, taking care to maintain an unpainted line down the center.

1

2

2a

2b

3

RUSCUS

Ruscus is a florist's favorite for wreaths and garlands. With long, abundant stems, glossy green leaves and little berries, it is a brilliant opportunity to practice consistent leaf painting.

The ruscus leaf is long and slim with smooth edges. Each leaf can be made in two brushstrokes: either mirrored S-curves or a C-curve and an S-curve. Ruscus leaves have plenty of curl, so play around with changing the bends and directions of your leaves by varying your brushstrokes.

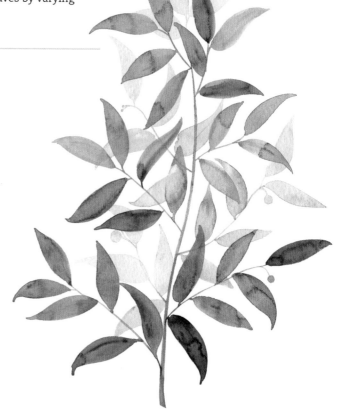

WHAT YOU WILL NEED

Brushes
Size 2
Size 8

Colors

Sap Green

Green Gold

IN MINIATURE

1

2

1.
Using a size 0 brush for the whole mini project, paint a stem and some branches with leaves in diluted Sap Green. Allow to dry.

2.
Paint more concentrated Sap Green branches with leaves in the gaps and paint a fine line of green down one side of the stem to add depth.

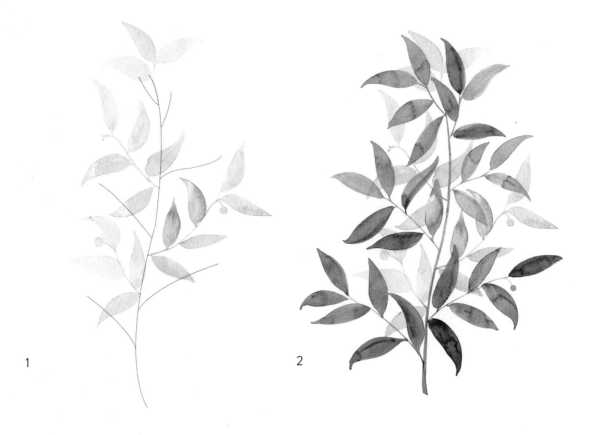

1.

Draw a faint pencil stem that is long and curved with plenty of alternating branches. A ruscus has many overlapping leaves.

Starting at the top, paint alternating branches down each side of the main stem in a diluted Sap Green with your size 2 brush. While still wet, add diluted Sap Green leaves with your size 8 brush.

Ruscus branch tips often have a small round berry. Paint a few berries in diluted Green Gold at the end of your wet Sap Green branches and allow to blend. Leave to dry fully.

2.

Repeat step 1 with a more concentrated Sap Green, filling in the unpainted branches. As you work your way down, fill in the main stem in Sap Green.

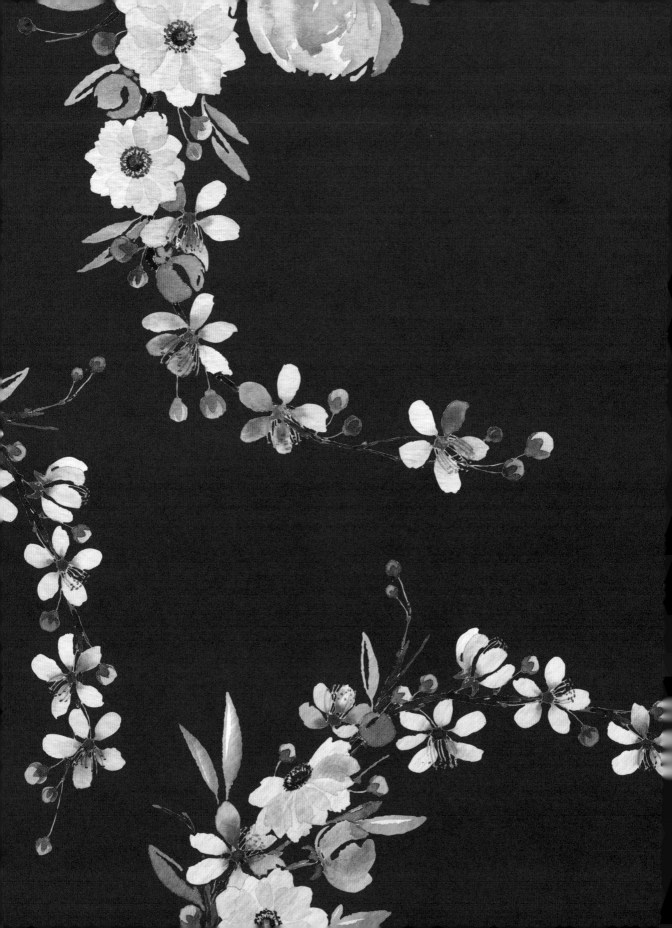

DECORATIVE BOTANICALS

WREATHS

Gather together your blooms, it is time to put some arrangements together. I like to choose no more than three focal flowers (the most prominent flowers in an arrangement), two fillers (less detailed flowers to fill in the spaces) and a range of foliage that suits the flowers' color palette. For this wreath project, I have chosen roses and peonies with eucalyptus, ruscus and berries.

You can either stick to the colors established in the projects or try painting these flowers in a new palette. Just remember to reference the color wheel and play around with color swatches beforehand.

Having the basic outline of a circle – or any shape for that matter – anchors the plants in place so you can't go too far wrong. I paint a mixture of full-sized plants as well as their miniature, simplified counterparts in my wreaths. Working with a small brush helps you to fill in all the little spaces.

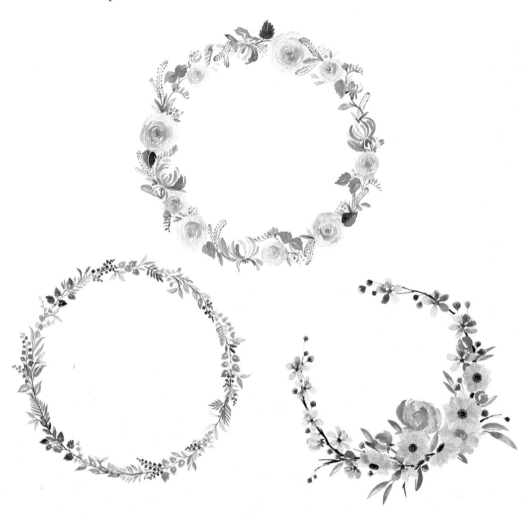

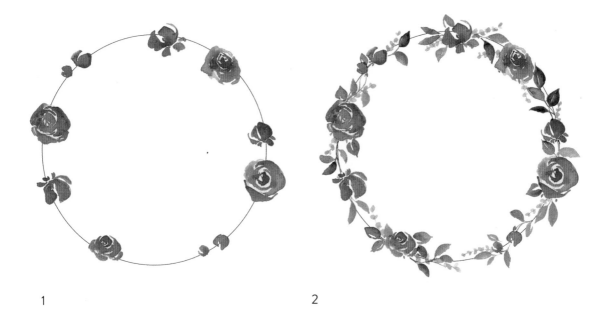

1

2

FLORAL WREATH

1.

Choose your color palette then draw a faint pencil circle. Start with your focal flowers as it is much easier to add in the foliage and filler plants after these have been positioned. Allow to dry fully.

2.

Add your foliage, thinking about the direction of your stems. Are they all going to be facing in the same direction or will they burst out in opposing angles, creating abundant clusters? Allow to dry fully.

3.

Add your filler flowers, then step back and look at the wreath as a whole as you may need to do some shaping. Fill in any gaps with what you feel is lacking in that particular area. I always find a few berries are perfect gap fillers.

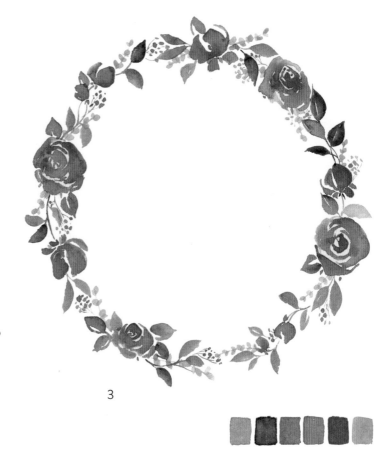

3

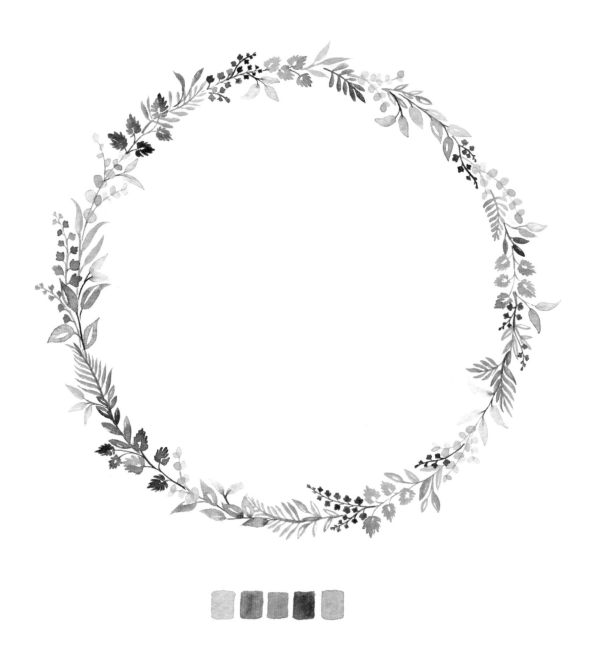

FOLIAGE WREATH

Fancy something a little
different? Try out a foliage
wreath and see how many
shades of green you can create.

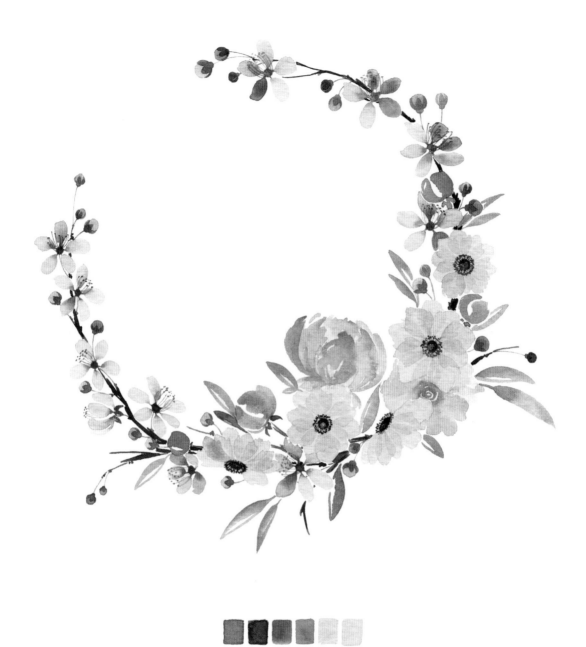

ASYMMETRICAL WREATH

There is no need for a wreath
to be a complete circuit, nor
does it need an even distribution
of flowers along the length.

ARRANGEMENTS

The most successful painted arrangements rely on a fluidity of movement. My favorite floral arrangements have a wild quality to them – the stems are free to curve in all directions and blooms bounce luxuriously.

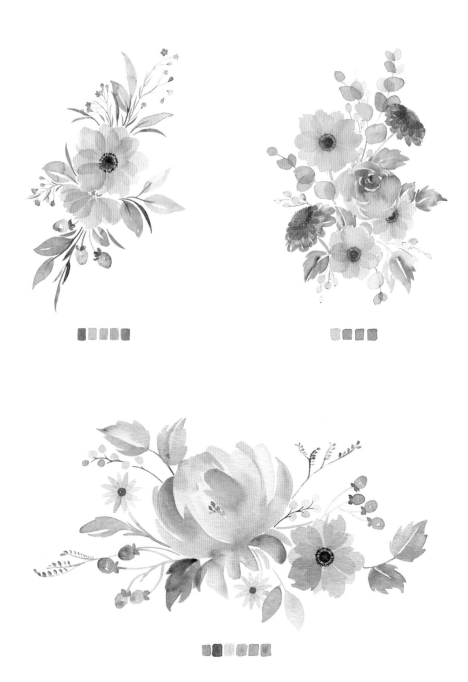

SMALL ARRANGEMENT

This small buttonhole arrangement requires a single focal flower and simple filler flowers and foliage. It is based on one long S-curve.

1.

Draw a long pencil S-curve (shown in green) diagonally across your page. Paint two focal flowers of differing sizes or angles along the center of this curve (I have chosen to use an anemone). The rest of the foliage needs to feel as if it is emanating effortlessly from this central cluster. Draw curved stems branching off from the central S-curve and from between the two flowers. Look at the length of these pencil stems and consider how they affect the shape of the arrangement as a whole.

2.

Choose two filler flowers (I have chosen waxflower and hypericum berries) and two foliage types (I have opted for a broad leaf in Sap Green/Cadmium Yellow and a thin leaf branch in Sap Green/Hooker's Green). Work on one plant at a time, starting with the one with the broadest leaves or largest petals, and making your way down to the smallest. I started this with the broad green leaves and ended with the waxflower. Allow for unpainted space between your stems and flowers; it gives the piece a loose feel, as if the plants are floating and not tightly bunched. At each stage, take a step back and view the piece as whole – you might want to add a few more filler flowers or foliage in places as the piece takes shape.

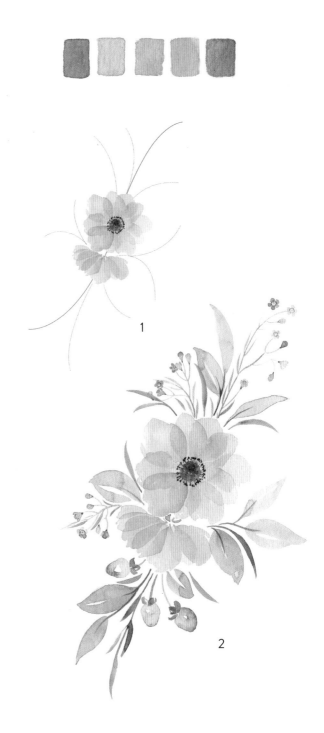

LARGE ARRANGEMENT

A blank page can be an intimidating sight when starting a large arrangement. I start my pieces just as a florist would begin a bouquet: with triangles.

1.

Choose three focal flowers (I have chosen dahlia, rose and anemone). Place them on the page in two overlapping triangles. Try to imagine what angle you will be seeing of each flower.

2.

Draw faint pencil curves emanating from the center of the arrangement for your foliage and filler flowers – this is where you can create the shape of the piece as a whole. Work on one filler/foliage plant at a time, making your way from largest to smallest. Here, I started with the eucalyptus.

3.

Fill in any gaps with your smallest filler flower – in this case it was an assortment of berries.

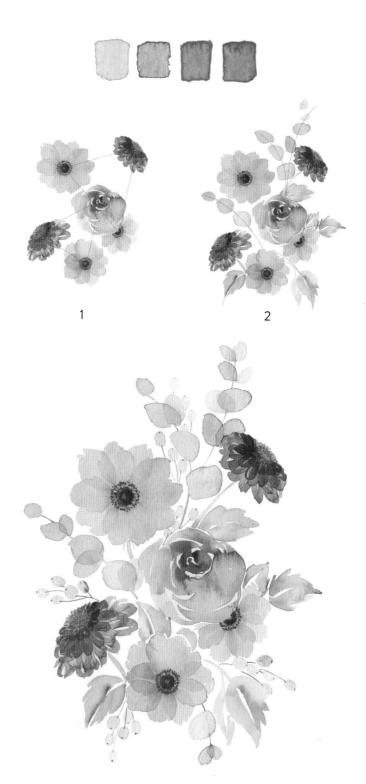

1

2

3

FLAT ARRANGEMENT

Starting with a basic outline allows you to create an arrangement in any shape. This flat arrangement started with a central peony with horizontal S- and C-curves emanating from it, which I then built up and shaped with foliage and filler flowers.

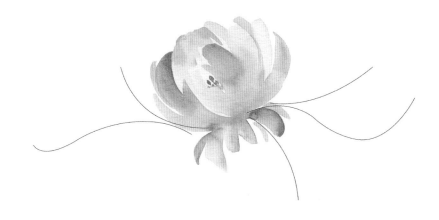

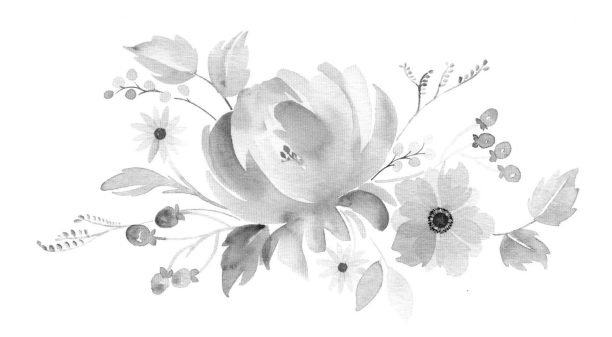

BORDERS

You can use negative space to create crisp, contemporary shapes for your abundant blooms to be placed against. Painted borders can be achieved either by drawing a pencil outline or using low-tack washi tape to mask out a shape. Here we try both techniques and see what painting opportunities each one offers. ·

PENCIL BORDER

I have chosen a vivid palette, rich with colors of palms, proteas and peonies. Each step works toward creating full borders, but you can also use this as a handy guide for creating corner details by following the first three steps.

Drawing a pencil border allows you to overlap plants over the front of the shape, you just need to be extra careful when painting close to the outline. It is difficult to fully erase pencil that has been painted over, so keep your lines faint.

1.

This project uses a rectangle. Draw your pencil outline and choose two diagonally opposite corners. In the top corner the plants will appear from behind the shape and at the bottom corner they will be in the foreground. Draw a large faint circle in the top corner and a smaller one in the bottom corner to create a guide for the reach of your plants. This asymmetry creates a pleasing aesthetic and draws the eye across the piece from left to right. The part of the circles that overlap the box make good starting points for your first few painted stems.

1

2.

Paint your top-corner plants in a fan. The key to successful borders is to keep the stems curved and keep varying your angles as you work along.

3.

In the bottom corner, paint a cluster of flowers and stems over the top of the pencil shape. If you just want to create border accents, this is a really nice place to stop.

4.

To complete the border, ensure the remainder of the border does not reach out as far as your accent corners. Keep varying the angle of your stems. Take your time, look around the border you have painted so far and see what color/flower/leaf you haven't used in a while to keep the variation consistent. Once fully dry, rub out any visible pencil.

2

3

4

WASHI TAPE BORDERS

This technique allows you to be a little more loose in your painting style as the tape will maintain a lovely crisp line. It just means that the flowers will look as though they appear from behind the masked shape. The satisfaction of peeling away the tape to reveal a crisp line is one of life's tiny pleasures. I recommend testing out the tape on your watercolor paper before you paint your masterpiece. Some tapes are a little bit too sticky and pull up the watercolor paper. Washi tape works far better than masking tape.

Full Border

Once you have masked your area (make sure all the edges are properly smoothed down) load up your brush with lots of wet color and paint loose watercolor florals to your heart's content. I made a point of bleeding each leaf and each flower into each other to create a full border of peonies. Allow to dry fully before carefully peeling the tape away.

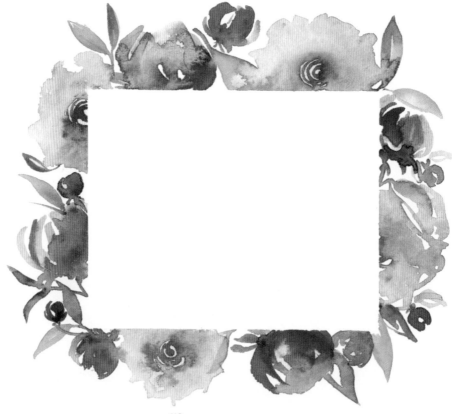

Line Border

This technique can also be used to create long lines of painted borders and is just as effective with a less loose style. When painting spaced, thin stems along a masked line, it is important to pack them together fairly tightly and paint a few leaves and thicker lines across the masked line. If you have too much negative space, you will lose the sense of a crisp border line when the tape is peeled away.

HOUSE PLANTS

I have a thing for house plants, to the extent that we are working on a one-in-one-out basis at home. Once every window sill was full, I turned my attention to my sketch pad and delighted in painting lines of miniature plants in pots. The joy of choosing a container is just as satisfying as picking the plant itself. For these projects, you will create beautiful pots in which to paint your plants.

Plant containers vary in shape and size, and come covered in all sorts of patterns. It would be impossible to depict every style. Here, you will find a breakdown of my favorite designs to provide inspiration for your very own collection.

Look back through the foliage section for miniature palms and ferns to paint in these pots. You'll see there are a couple of new ones in this project to try out, too.

WHAT YOU WILL NEED

Brush
Size 0

Colors

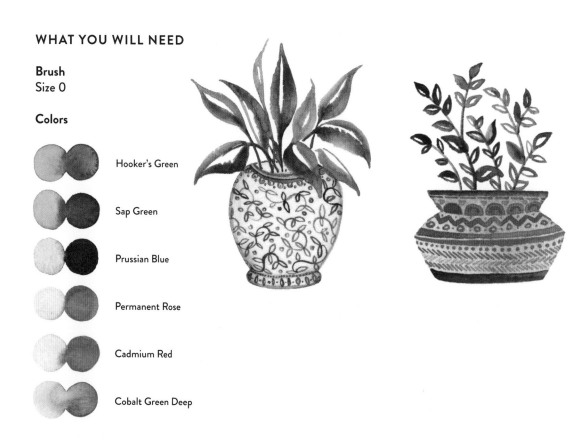

Hooker's Green

Sap Green

Prussian Blue

Permanent Rose

Cadmium Red

Cobalt Green Deep

DELFTWARE

Be it a Delftware or Willow pattern, blue-and-white china pots are my all-time favorite. I don't know a household that doesn't own a piece and charity shops provide me with a steady supply of them. This painting project uses just one color for the pot: Prussian Blue on an unpainted base.

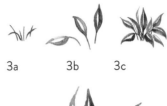

3a　　　3b　　　3c

1　　2　　3　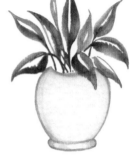

1.
Wet your size 0 brush and load it up with Prussian Blue. Treat your brush as a fineliner pen to draw the pot's outline – using a wet brush will ensure the paint will run off as smoothly as ink from a felt tip. Paint the sides and base of your pot (you can draw it in pencil first but I find these pots are more charming when painted freehand).

2.
Clean your brush and while still wet, stroke the inner sides of the blue outline and allow a little color to blend to create a little shadowy depth. This will give the pot a more 3D appearance.

3.
This is the point to add your foliage, whatever it may be. You can fill in the top rim of the pot once your leaves have been painted in.

4.
Add a pattern in Prussian Blue with your size 0 brush. I find there is always space for a little more pattern and detail, even when you think you've covered every corner.

4a

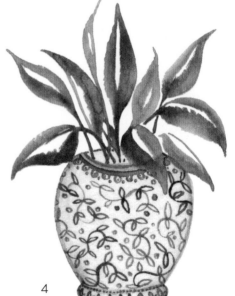

4

COMPLEMENTARY COLORS

Pink, red, navy and turquoise all together on one plant pot shouldn't work, but they do. This pot starts with a colorful base. Remember to dilute your base color so the pattern will show up over the top.

1

2

3

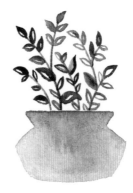

1.
Load up your size 0 brush with diluted Permanent Rose. Paint an outline of your pot.

2.
Before it has a chance to dry, fill in the shape with water.

3.
This is the point to add your foliage, whatever it may be. The plant base should be pale enough for you to be able to paint leaves bending down over the front.

3a

3b

4a

4.

Once your base is completely dry, add rows of pattern with your size 0 brush. Stack up rows of simple shapes in complementary colors and watch the pot come to life.

4

PATTERN

Abstracting your botanical studies into patterns is satisfying and addictive. Here are two projects to create some glorious plant patterns.

LAYERED PATTERN

Working in diluted shades gives each layer a delicate translucence, bestowing a light energy to the painted layers. I think you could get away with a fourth layer, but building too many will overload the piece and lose the detail.

1.

Choose a diluted color and a plant. Paint sparsely placed stems, always working in curves. If you struggle to paint the plant in a variety of shapes and positions, keep turning the page round each time you start a new stem. Allow to dry fully.

2.

Repeat step 1 with a different color and plant. Fill the gaps but also allow for some plants to overlap with the previous layer. Allow to dry fully.

3.

Repeat step 1 with a third color and plant. Make a point of filling in the gaps and shaping the pattern as a whole with this last layer.

1

2

3

BLUE PATTERN
Working in a single color is a great showcase of watercolor's variety of tone and value. This was painted in Prussian Blue.

1.
Mix diluted and concentrated versions of the same color in separate wells of your palette. Paint a range of focal flowers, spaced across the page at varying angles and using different values of the color. Allow to dry fully.

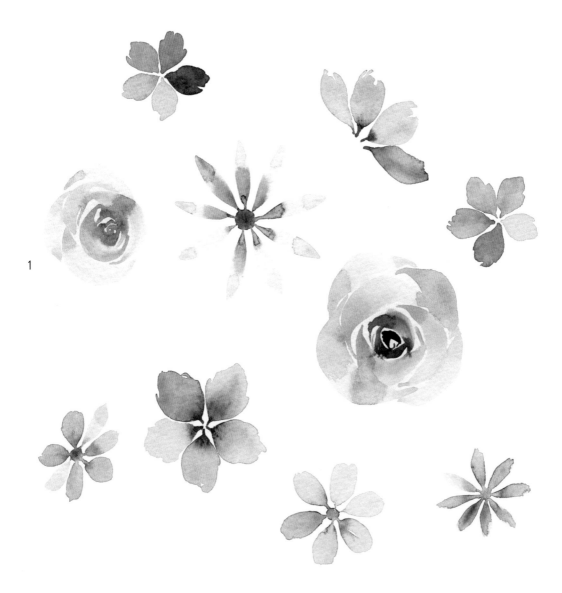

1

2.

Fill the gaps with your choice of foliage and filler flowers. Keep turning the page to achieve new angles.

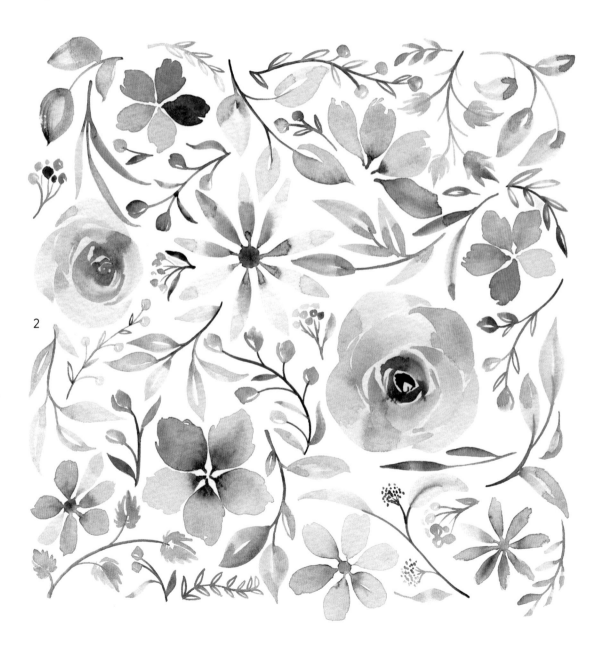

ACKNOWLEDGMENTS
Thank you

To Helen, who saw my potential. To Xanthe at Ivory Flowers who let me come and play. To Kirsten for suggesting I might try painting in watercolors. To the team at Octopus whose enthusiasm for my first attempt at authoring made this process all the more fun. To my parents who encouraged me to pursue my passions, and who never let me know whether or not they felt a career in the arts was a risk. To Anna, Andy, Hugh and Meera for big brotherly and sisterly advice along the way. To my gang of creatives, who embraced me in a community of brilliant, brave individuals turning their passions into business. To my best friends who have supported me and celebrated each mini milestone. To Emma, Jon (my flower dealer) and Hayley for regular flower and plant tutoring. To Ant and Kala who are in between every line of this book.